LOST
WASHINGTON, D.C.

LOST

WASHINGTON, D.C.

··· JOHN DeFERRARI ···

Foreword by James M. Goode

Charleston · London

THE
History
PRESS

Published by The History Press
Charleston, SC 29403
www.historypress.net

Copyright © 2011 by John DeFerrari
All rights reserved

First published 2011
Second printing 2011

Manufactured in the United States

ISBN 978.1.60949.365.3

DeFerrari, John.
Lost Washington, D.C. / John DeFerrari.
p. cm.
Includes bibliographical references and index.
1. Washington (D.C.)--Buildings, structures, etc.--History. 2. Neighborhoods--Washington
(D.C.)--History. 3. Washington (D.C.)--Social life and customs. 4. Washington (D.C.)--
Description and travel. 5. Buildings--Washington (D.C.) 6. Lost architecture--Washington
(D.C.) 7. Washington (D.C.)--History. I. Title.
F204.A1D44 2011
975.3--dc23
2011034748

This book is for Sue.

CONTENTS

CONTENTS

FOREWORD

The vast number of lost landmarks, both grand and humble, that witnessed the historical development of Washington but are now either gone or significantly altered is astonishing. Every block throughout the city's central core has seen change. Old structures have been replaced with new ones that were thought better or more fashionable or perhaps just more profitable. With so few past landmarks preserved, it is easy to lose sight of the rich heritage of the city's architectural landscape, and thus it becomes ever more important to retell the stories of these lost places for new audiences.

Lost Washington, D.C. casts a wide net to gather together a sampling of such stories. There are stories here about theaters and restaurants, hotels and houses, a hospital and a stadium—locations where everyday life took place. To read about how these buildings were erected, as well as the people who influenced their construction and use, is to recapture a bit of the life of the city and its inhabitants in bygone days.

This book is one of several that recollect the vanished places and people of the District of Columbia, and it is a valuable addition to a body of work that includes lively stories meant for sheer entertainment as well as more scholarly studies that push the borders of our understanding of the past. Perhaps *Lost Washington, D.C.* will bring new readers to discover this richly fascinating realm.

James M. Goode
April 2011

James M. Goode is author of several landmark studies of the architectural heritage of Washington, D.C., including Capitol Losses: A Cultural History of Washington's Destroyed Buildings, Best Addresses: A Century of Washington's Distinguished Apartment Houses *and* Washington Sculpture: A Cultural History of Outdoor Sculpture in the Nation's Capital. *He was a recipient of the Patterson House Preservation Award in 2006 and the Glenn Brown Award from the D.C. Chapter of the American Institute of Architects in 2008. Mr. Goode is currently at work on a book about the historic houses of Washington, D.C.*

PREFACE

P eople forget so quickly," Librarian Jerry McCoy remarked to me one day when I was in the very early stages of my research for this book. It's often difficult to remember specific facts even in the recent past (was that restaurant there on the corner ten years ago, or twenty?) much less imagine the city a century ago, but how wonderful it would be to bring some of these forgotten moments back to life.

I've always been fascinated by Washington's rich history and have always wished that I could step into the shoes of a Washingtonian on downtown's busy streets at the turn of the past century, with all of the horses, carriages and trolley cars, the shop fronts spilling their wares out in sidewalk displays and the broad awnings shading passersby from the noonday heat. For some years, I collected vintage postcards that offer colorful, fleeting glimpses of those times. Then, in 2009, I started researching and writing stories to try to bring to life some of the scenes in these postcards, and those stories first appeared in my blog, Streets of Washington (http://streetsofwashington. blogspot.com). That blog, in turn, became the starting point for this book.

There are many, many stories that could be included in such a book, and this selection represents only a taste of them. This is a book for Washington residents, people who know about life in the city now and want to read stories about what it was like back in the day—way back. It is meant to reflect the collective experience of Washington's citizenry. Some of the stories touch on the city's earliest days, but the emphasis is on the first decades of the twentieth century, when Washington City was quickly expanding to fill out the District of Columbia. My aim has been to cover a variety of

landmarks—restaurants, theaters, hotels, office buildings and the like—that might be known or encountered in one way or another by a typical resident of the District, many of whom lived or worked downtown. These places were very well known and frequented in their day but are often forgotten now. The stories about them touch on the people who left their marks on these places, in terms of both architecture and the cultural life of the city.

The goal here is not to be comprehensive, either by location or type of landmark. Each of the stories is intended to be in-depth enough to give the reader a sense of intimacy with the subject and yet still remain brief and easily accessible. The stories are arranged by neighborhood so as to allow readers to keep their geographic bearings, but there isn't room here to do full justice to any of these neighborhoods, and many, regretfully, are not covered at all. The stories I've chosen all seemed to me to represent some pivotal aspect of Washington life, and I hope they speak to you as they have to me.

This book would not have been possible without the assistance and encouragement of many people. The first place I always turn to for research assistance is the Washingtoniana Division of the D.C. Public Library, located at the Martin Luther King Jr. Memorial Library downtown. The staff there are always helpful and welcoming and have facilitated many exciting discoveries. I am particularly grateful to Jerry McCoy, who serves as Special Collections librarian there and has encouraged and assisted me from the first days when I began my blog on D.C. history.

Rebecca Miller, executive director, and Amanda McDonald, administrative manager, of the D.C. Preservation League, were also very generous in opening up their archives and providing assistance, as did Kim Williams, National Register coordinator, and Bruce Yarnall, operations and grants manager, of the D.C. Historic Preservation Office. I also received helpful assistance from J. Theodore Anderson, director of the National Presbyterian Church Library and Archives; Diana Kohn, president of Historic Takoma, Inc.; and from the Library of Congress. Hannah Cassilly and the staff of The History Press ensured that the book's production would be first-rate.

I would especially like to thank James M. Goode for his thoughtful mentorship in exploring Washington's architectural history, as well as his helpful suggestions for this book. Matthew Gilmore, who suggested that I undertake the book, deserves much credit for the beautiful map of historic sites. Frances White also went out of her way to give me sage advice and lots of much appreciated assistance. Lastly, and by far most importantly, I could never have undertaken this project without the unstinting support and enthusiastic encouragement of Susan Decker, to whom I dedicate this book with all my love.

Part I
GLIMPSES OF CAPITOL HILL

The Capitol Hill neighborhood held great promise when the new city of Washington was being developed in the 1790s. The area between the Capitol and the Anacostia waterfront was expected to be a prime location for development, and it was the focus of much attention. George Washington, a great landowner and speculator, decided to make a modest investment there, and many others did as well. However, it soon became clear that the city's downtown was going to be to the west, between the Capitol and the White House, rather than to the east. Capitol Hill instead developed as a largely residential enclave with an early emphasis on housing for workers at the Navy Yard. The presence of the military has always had a strong influence on the character of the Hill, and its impact was seen most vividly during the Civil War, when the area was flooded with wounded who were cared for at Providence Hospital and other makeshift facilities.

GEORGE WASHINGTON'S TOWNHOUSES

George Washington had an abiding interest in real estate and was intimately involved in the development of the new capital city in the 1790s. The city had been slow to develop in its first decade, and in 1798, prominent local landholders, including Thomas Law, convinced Washington to invest directly in city property by purchasing a pair of lots close to the Capitol grounds on North Capitol Street. A pair of substantial townhouses at this location

would be excellent investments, it was argued, as they could be rented out to congressmen who would be moving to Washington with the federal government in 1800. Washington commissioned his good friend Dr. William Thornton—architect of the Capitol—to oversee construction of these townhouses. To perform the work, he hired George Blagden, superintendent of the masons working on the Capitol building. In one of many letters to Thornton, Washington described the start of the project, at which point he already was thinking of design enhancements:

> *Enclosed is a check on the Bank of Alexa for five hundred dollars, to enable Mr Blagden by your draught, to proceed in laying in materials for carrying on my buildings in the Federal City.*
>
> *I saw a building in Philadelphia of about the same dimensions in front and elevation that are to be given to my two houses—which pleased me.—It consisted also of two houses united, Doors in the Center, a Pediment in the Roof and dormer windows on each side of it in front, Sky lights in the rear.—*
>
> *If this is not incongruous with the Rules of Architecture, I should be glad to have my two houses executed in this style.—*
>
> *Let me request the favor of you to know of Mr Blagden what the additional cost will be.*[1]

In a later letter, he described the houses more fully:

> *Although my house, or houses (for they may be one or two as occasion requires) are I believe, upon a larger scale than any in the vicinity of the Capitol, yet they fall short of your wishes...The house are three flush stories of Brick, besides Garret rooms;—and in the judgement of those better acquainted in these matters than I am, capable of accommodating between twenty and thirty boarders.—The buildings are not costly, but elegantly plain and the whole cost, at pretty near guess, may be between 15 and 16 thousand dollars.*[2]

Once work began on the houses in December 1798, Washington took a keen interest in their construction, often inspecting progress on the work with Dr. Thornton at his side. Although the houses were unfinished at the time of Washington's death a year later, they were finished by his nephew and heir, Supreme Court justice Bushrod Washington, who apparently had a woman named Mrs. Frost operate them as a Congressional boardinghouse,

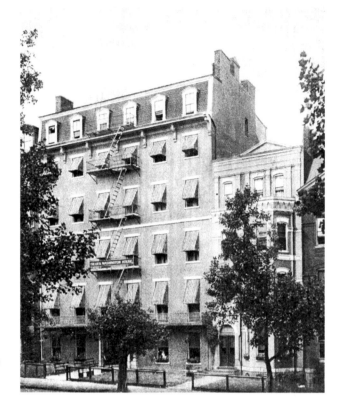

Postcard view of
George Washington's
townhouses from
1908, when they were
the Hotel Burton.
Author's collection.

as George Washington had envisioned. Several prominent early legislators
stayed there, including Speaker of the House Nathaniel Macon of North
Carolina and William Crawford of Georgia.

The next climactic event for the townhouses, as well as the city in general,
was the invasion of the British in August 1814, when the Capitol, White
House and other public buildings were burned to the ground in a catastrophe
that was deeply humiliating for the fledgling city. In the midst of the chaos,
the Washington townhouses were burned down as well, though they might
not have been deliberately set alight. Anthony Pitch has suggested that the
fire could have been accidental, if strong winds from the burning Capitol
had carried hot embers to the houses and caught them on fire.[3] On the
other hand, there were reasons that the British could have been provoked
into burning these structures. In the process of trying to protect official
documents in advance of the invasion, Congressional clerks had stashed
the records of several committees in "the house commonly called General
Washington's," according to a later report.[4] If the British knew this, it would

certainly have been reason enough to torch the buildings. Whatever the cause, the houses went up in flames.

The ruins were then sold in 1817 by George C. Washington, grandnephew of the president. Peter Morte gained ownership and incorporated the remaining walls into a rebuilt house that he opened as a boardinghouse.

By about 1840 or so, the house came into the possession of Rear Admiral Charles Wilkes (1798–1877), a colorful explorer and prominent figure during the Civil War. Wilkes led a famous expedition to explore parts of the Pacific from 1838 to 1841. During the Civil War, he took controversial actions—such as blockading the port of St. Georges in Bermuda and boarding a British ship there—that could have provoked the British to side with the Confederacy. Wilkes had a reputation for being arrogant and capricious, was a harsh disciplinarian at sea and may have been a model for Herman Melville's Captain Ahab in *Moby Dick*.

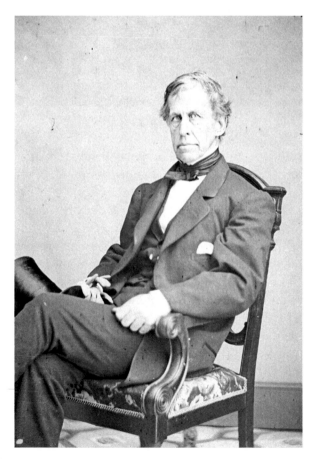

Civil War photo of Admiral Charles Wilkes, who may have been a model for Herman Melville's Captain Ahab. *Library of Congress.*

At the time Wilkes owned Washington's townhouses, the immediate neighborhood was growing into a beehive of activity. In 1848, North Capitol Street was graded, lowering it ten feet in front of the houses, and Wilkes responded by building a stone wall to protect his property. Then in 1851, the street was graded again, lowering it another fifteen feet. All of this work had been precipitated by the project beginning in 1850 to enlarge the Capitol building. Massive marble blocks, shipped into town by rail, had to be drawn down North Capitol Street to the building site, and grading of the road became a necessity to accommodate this traffic. As a result, the Wilkes house ended up perched precariously on the tuft of an artificial hill until about 1870, when Wilkes had two stories added underneath the original building to extend it to street level. At this point, the former twin three-story townhouses had evolved into a sizable, five-story building, more a full-fledged hotel than a boardinghouse, and that is what they soon became.

In about 1876, the building was acquired by Nelson J. Hillman, who operated it as a hotel called Hillman House until at least 1896. It was subsequently renamed the Kenmore Hotel, and as such it achieved its greatest notoriety. In the wee hours of May 15, 1901, what the *Washington Post* called the "most mysterious murder that has occurred in Washington within a quarter of a century" took place there.[5] A twenty-one-year-old Census Bureau clerk, James Seymour Ayres, was shot to death in a fourth-floor room of the Kenmore. His assailant had apparently used Ayres's own revolver against him and then left it behind at the scene of the crime. Neighbors in the hotel heard the shots, and some even heard groans and cries for help, but none ventured out of his or her room to see what had happened. A neighbor in an adjacent building looked out and saw a shadowy female figure in stocking feet silently escape from Ayres's window, descend two flights down the fire escape and slip back into another hotel window. No clear identification could be made in the darkness. Police later found a bloody handprint on the window sill and bloodstains on the fire escape.

The sensational case gained national attention because of its overtones of an illicit affair; an anonymous letter had been sent to the Congressional sponsor of the young Ayres, alleging that he was "associating with women and dissipating." He was apparently popular with "all of the women at the Kenmore," whatever sorts they may have been, and was known to have had tumultuous relationships with more than a few of them, as well as with women he met at the Census Bureau, which was located only about a block away. He even had reportedly intimated that he was in a troublesome relationship with a married woman at the hotel and would be moving out soon.

Suspicion soon began to focus on that woman, Mrs. Lola Ida Bonine (1866–1949). Five days after the murder, she turned herself in to police and confessed. According to Bonine, Ayres had lured her to his room on the pretext that he wanted to discuss the differences between them. Once she was in his room, he drew his gun on her and announced, in so many words, that he was going to rape her. Mrs. Bonine, naturally, had no choice but to wrestle the revolver away from Ayres, shoot him three times with it, take off her shoes so as not to make any further noise, descend the fire escape to her apartment, clean herself up and calmly tuck herself into bed. After laying all of this out for police, she noted that, at her husband's suggestion, she had learned the art of self-defense against assaults, and this is what had saved her. The police promptly arrested her.

Despite the implausibility of her story, Bonine garnered sympathy from the start. She was married to a respectable businessman and had two sons, aged fifteen and thirteen. Everybody thought that she was the nicest person. Her trial, beginning in late November, raked over many sordid details of the crime and challenged all of the unbelievable aspects of her claims about what had happened, but in the end, after nearly a month's proceedings, she was acquitted. The jury had bought her story.

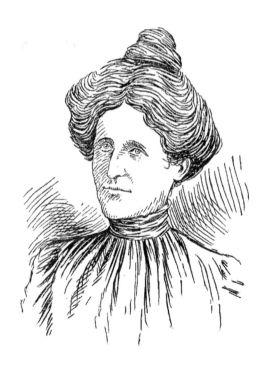

Mrs. Lola Ida Bonine was acquitted of the murder of James Ayres in 1901. *After a drawing published in the* Washington Post.

By the following year, the Kenmore had closed, and the building was vacant. The *Post* reported in August that passersby invariably wanted to know which window was the one to the murder room (that one over there, on the fourth floor, without a curtain). "Many strangers, who are unaccompanied by a resident of Washington, and desiring to know the exact location of the room in which the tragedy occurred, frequently go out of their way and make inquiries of the firemen of Truck A, which is located directly opposite the hotel."[6]

The hotel was later reopened for several years as the Hotel Burton and, after that, as the Washington Inn. The existence of a fire station across the street came in handy early in 1912 when the hotel caught fire. Everyone was saved unharmed from the severely damaged building, except for "Cap," a beloved little fox terrier that had suffocated behind a closed door. The police suspected (with what evidence, it is not clear) that a former janitor who had been fired a month previously had set the fire.

By this time, the sweeping vision of the McMillan Commission for a grand, monumental core to the city had firmly taken hold, and plans were afoot to raze whole blocks of the old brick houses around the Mall that had witnessed so much history. In 1913, the government bought up all the buildings on either side of the 200 block of North Capital Street in preparation for creating a vast open plaza that would stretch between the Capitol and Union Station. The buildings were all promptly demolished, although construction of the plaza was not completed until 1931. In 1932, on the occasion of the bicentennial of George Washington's birth, the District of Columbia donated a historical marker that was set in place in the plaza at the location of the townhouses that originally had been built by our first president. It is the only reminder left of this site's rich and dramatic past.

PROVIDENCE HOSPITAL, WASHINGTON'S OLDEST

On the other side of the Capitol, just a few blocks south of the Library of Congress, once stood the city's largest and most prestigious hospital, founded in the urgent, needy days at the dawn of the Civil War. Because the modern Providence Hospital is now located in Brookland, away in the northeast quadrant, it can be easy to forget how important this institution was for the rapidly growing city in the late nineteenth and early twentieth centuries.

Before Providence, there was only one hospital in the city, and it was a rather sorry one—the Washington Infirmary on Judiciary Square, which

had been converted from an old jail in the 1840s. In April 1861, after war was declared, this hospital was taken over by the military, and a new hospital for the general population was urgently needed. The pioneering Dr. Joseph M. Toner (1825–1896), a leader among the city's physicians and the future founder of the Columbia Historical Society, helped convince the Daughters of Charity of Saint Vincent de Paul, which had been running the St. Vincent's Orphanage and School downtown, to open a new hospital. The site chosen was the old Nicholson mansion at 2nd and D Streets, SE, which was made available by descendants of Daniel Carroll, one of the original major landowners of Washington.

The hospital was established just before the Battle of Bull Run, the first major engagement of the war, when no one was imagining yet what horrors would await medical facilities like Providence. A notice in the *National Intelligencer* about the opening of the hospital—just a month before Bull Run—paints an idyllic picture:

> *The* [Nicholson mansion] *is large and airy, the location high and healthy, and the grounds extensive and beautifully ornamented with shade and fruit trees, and gravelled walks. We can imagine what a relief it would be to the invalid to be transferred from the hot and dusty city to the grateful shade of this cool and quiet retreat.*[7]

It didn't work out quite like that. After Bull Run and subsequent Civil War battles, the wounded began pouring into Washington. Numerous temporary hospitals were constructed or government buildings requisitioned as infirmaries throughout the city. At Providence, the beautifully ornamented grounds were soon full of tents groaning with the wounded, as the hospital building itself could accommodate very few patients. The "high and healthy" perch on Capitol Hill became known as Bloody Hill as Providence cared for countless soldiers from both the North and the South throughout the conflict.

After its wartime baptism by fire, Providence continued as the city's preeminent hospital under the leadership of Sister Beatrice Duffy (circa 1827–1899), as well as Dr. Toner, who became the house physician. A Congressional charter in 1864 was followed by several appropriations that allowed the hospital to begin constructing a large new building in 1866.

Completed in 1872, the Second Empire–style main hospital building had a rather stiff, institutional look. Architectural historian James Goode has described it as combining a "bracketed" Italianate vocabulary—wide-

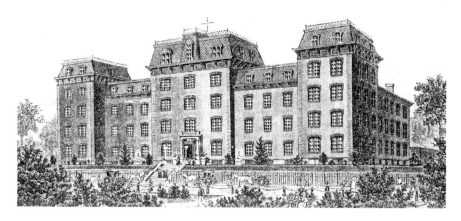

Providence Hospital circa 1891, *Washington Herald*.

bracketed eaves, a flat façade and heavy lintels—with Second Empire motifs, such as a mansard roof and delicate ornamental ironwork cresting.[8]

With 250 beds, the hospital remained the largest in Washington through the turn of the century, despite the arrival of a number of competing institutions. Providence offered a range of accommodations, from indigent wards (simple beds lined up in large halls) to private suites, complete with bedroom, bath and large parlor with fireplace, at a cost of fifty to seventy-five dollars weekly.

Providence made many innovations in those days. Whereas other hospitals had "closed staff," restricting patient care to their own physicians, Providence had an "open staff" policy, allowing patients' doctors to care for them while admitted to the institution. It became a teaching hospital, opening the first surgical amphitheater in 1882, where Georgetown University medical students first studied before their own hospital was built. The city's first contagious disease ward was opened at Providence in 1895, the first outpatient clinic in 1907 and first cardiac unit in 1908.

By the 1880s, the once capacious hospital was becoming crowded. In 1886, the *Washington Post* noted, apparently with alarm, that "[s]o urgent are the demands upon the hospital that the wards originally set apart for colored patients exclusively are used by both white and colored, the same being the case in the female ward."[9] New buildings were added, including a separate building for the contagious ward in 1899 and a nurses' home in 1901. With federal funds, the hospital was finally able in that same year to embark on a substantial expansion program, completely remodeling and

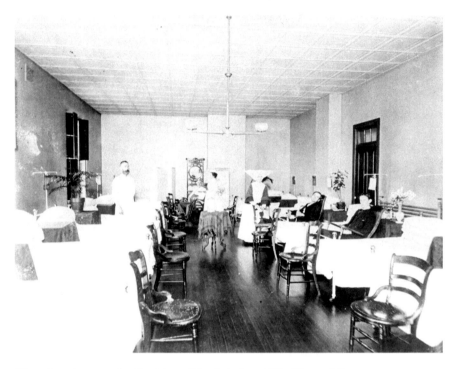

View of a private ward at Providence Hospital, circa 1895. *Library of Congress.*

enlarging the existing building and extending it eastward, filling up the entire city square. The makeover, completed in 1904, was thorough both outside and in, with the former Second Empire building being transformed into a much larger Mission-style structure, a design being adopted for hospitals across the country. Prominent Washington architect Waddy B. Wood (1869–1944) was responsible for this transformation, which gave the building tiled roofs, stuccoed walls and a soaring 175-foot central bell tower. Inside it was finished in a dignified—and clean-looking—white marble. The cost was a staggering $530,000.

The Roman Catholic Daughters of Charity used Providence as a training ground for nurses, and these sisters ventured to the battlegrounds of the Spanish-American War and World War I to treat wounded soldiers, some of whom were then brought back to the hospital for convalescence. After the armistice ended World War I, large numbers of convalescing soldiers stopped at Providence before returning home.

After the U.S. entry into World War II, the population of the District mushroomed, and the infrastructure of the aging hospital was soon taxed

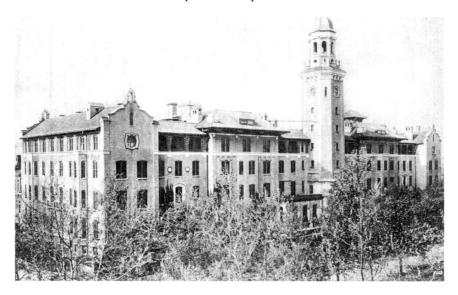

Postcard view of the remodeled Providence Hospital, circa 1910. *Author's collection.*

to its limits. In February 1942, the *Washington Daily News* reported that the obstetrics ward was lined with gurneys holding women who had just delivered babies or, in one case, were in the process of delivering, no hospital beds being available. Two more new mothers had to make do sitting in chairs.[10] Six years later, after the war had ended, another *Daily News* reporter found much the same situation: overcrowding throughout (including a former sun porch packed with beds) and outrageous inefficiencies. For example, at meal times, the elevator bank in one part of the hospital had to be closed off for passengers so that staff could use it to transport meals from the basement kitchen to rooms throughout the building. "We have great trouble keeping the food warm," one of the sisters observed in what seems like an understatement.[11]

Plans were already being made by that time to build a new hospital at a new location to replace the outmoded facility. In 1949, a fifteen-acre site at 12th and Varnum Streets, NE, was acquired from the Catholic University of America, and in 1952 the proposed eight-story, 350-bed replacement hospital was announced. A federal appropriation for District hospitals had been passed by Congress in late 1951, jump-starting the project with more than half of the $7 million that would be needed. The firm of Faulkner, Kingsbury and Stenhouse designed the new facility, which was opened in 1956 and continues in operation to this day.

Meanwhile, the site of the old hospital on Capitol Hill was destined for years of uncertainty as powerful competitors squabbled over its future. In the first years after moving, the Daughters of Charity kept ownership of the old building and leased it to the government. Then, in 1962, the organization sold the site for $670,000 to a partnership of four investors that included Max Bassin, founder of Bassin's Restaurant. The new owners wanted to build a high-rise apartment complex on the site, but their request for a zoning variance to do so was denied. Several organizations, including the National Capital Planning Commission, went on record urging that the historic hospital building be preserved, but no one came forward with a practical proposal or the funding to turn that dream into a reality.

The old building grew derelict as time went by, and after the last Commerce Department tenants left in 1964, it was heavily vandalized. Parts of it reportedly made their way on to other properties across Capitol Hill. The District condemned the tattered building in 1965, and it was soon torn down. Next, the owners proposed a parking lot for the vast newly cleared square, but that request was quickly rejected. The government finally bought the property from the four owners in 1972 for $1.4 million, giving them a tidy profit. More years then went by as new proposals—a school for Congressional pages or a parking lot for Hill staff—were proposed and rejected. Finally, in late 1978, funds were committed to landscape the empty lot and convert it into the restful park that remains there today.

Part II

EVERYDAY LIFE ON
PENNSYLVANIA AVENUE

This great ceremonial boulevard has been called "America's Main Street" because it is so central to the structure of the nation's Capital, connecting the White House with the Capitol building and thus symbolically cementing two branches of government. But beginning in its earliest days, Pennsylvania Avenue was also the center of the city's everyday commercial life—much more so than it is today. In the first decades of the nineteenth century, federal-style townhouses lined the avenue on both sides; many were soon converted from residential to commercial uses. On the end near the Capitol, savvy entrepreneurs began opening boardinghouses for congressmen, senators and other government officials, often for only part of the year. These boardinghouses then led to the city's first great hotels, which were almost all located along the avenue. The great Center Market, founded at the beginning of the nineteenth century, was directly in the middle, and as it drew customers on a daily basis to its meat and produce stalls, other retail businesses soon sprang up as well, including dry goods stores and, of course, banks. Being at the center of activity, the avenue was also the natural place for newspaper correspondents to congregate, and by the late 1800s, the colorful "Newspaper Row" was an established fixture at the western end of the avenue.

THE CHAOTIC EXUBERANCE OF CENTER MARKET

The intersection of 7th Street and Pennsylvania Avenue, NW, was once the most central location in the city, halfway between the White House and the Capitol on Pennsylvania Avenue and intersecting one of the few roads (7th Street) that led out of the city to parts north. Recognizing its centrality, George Washington designated this spot to be a marketplace. The first Center Market opened for business here in 1801 in a building designed in part by James Hoban, architect of the White House. In time, additional markets (including Western Market, Eastern Market, Northern Liberty Market and others) would be established as well, but Center Market was always the biggest and busiest.

In its earliest days, it was aptly known as the "Marsh Market"; Tiber Creek originally ran through the southern part of the market space, and fish vendors would store live fish in wire baskets that they lowered into the creek. A major effort was undertaken in 1823 to level and raise the ground so as to confine the creek to the Washington Canal bed along B Street (Constitution

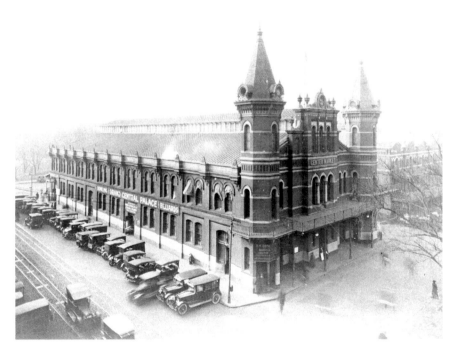

Center Market in the 1920s. *Library of Congress.*

Avenue). Despite the reclaimed *terra firma*, the Marsh Market was crowded and chaotic on market days; farmers from all parts congregated with their wagons, horses, livestock and produce; customers jockeyed for the best buys; and other assorted hucksters and hangers-on found ways to feed off the frenzy of activity. The marshy areas in the vicinity of the canal and market supported numerous waterfowl, and boys would happily find and shoot them and then immediately sell them to vendors in the marketplace.

By the 1850s, Center Market was an unsightly, unsanitary and overgrown sprawl of buildings and shacks that encroached on the streets around it and still barely contained all of the commercial activity it supported. Plans were made to modernize the old structures, but the Civil War intervened and postponed any action. In those days, a market such as this was a staple fixture of any large metropolitan area; local governments generally set them up in central locations and enacted regulations to encourage their use, ensuring that citizens of all means could have access to a broad range of affordable food. In the case of Center Market, the property was owned and operated by the federal government. An 1860 law turned it over to the city, provided that a new building was constructed within two years, which didn't happen. There followed considerable wrangling between obstinate individuals, both in Congress and the city government, over how a new market house should be funded and built. Finally, in 1870, Congress passed a law incorporating a private Washington Market Company to raise funds through the sale of stock to build the new market house. Company sponsors promised that "instead of the loathsome pile of rubbish" that constituted the existing market, they would build "a stately and elegant structure" with "magnificent entrances and porches to the edifices."[12]

Closely connected to both the D.C. government and the new market company was architect Adolf Cluss (1825–1905), who designed many prominent Washington buildings in the days when pressed red brick was king, including the original National Museum building on the Mall, the Franklin School and many others. For the new Center Market, Cluss created an elaborate square of four connected buildings with an open courtyard in the center. The design seemed to reach a compromise between the stateliness requisite of a grand Pennsylvania Avenue building and the Victorian eccentricities that were the fashion of the day. As with several of his other buildings, Cluss incorporated elements of German Renaissance Revival style into the structure's extensive decorations, which also included multiple stringcourses and fanciful towers. The rear and two side buildings containing the market wings and their twin-towered façades were completed

and opened on time in 1872, but the central building on the north side was not finished until several years later.[13]

At 57,500 square feet and with 666 separate vendor stalls, Cluss claimed in 1878 that the market was the largest in the country. It was designed to incorporate the most advanced ideas of the time, including two-story-high corridors to allow for plenty of ventilation, eight electric elevators, the city's first cold-storage vaults, its own artesian wells and an ice plant. While established merchants could rent out one or more stalls in the market itself, others with fewer resources could rent space in the courtyard and sell from their own makeshift stands.

One successful merchant was Louis P. Gatti, an Italian immigrant who operated a fruit and vegetable stand at Center Market from about 1900 to 1925. At his death in 1969, the *Washington Post* noted that Gatti's fruit and vegetable stand "won the culinary cachet of early 20th century Washington...[T]he fine quality of his fruits and vegetables—such as strawberries from Plant City, Fla., and typhoid-free watercress grown in pure mineral springs—won him an elite clientele of the rich and powerful in a day when even the most haughty of the city's housewives did their own daily

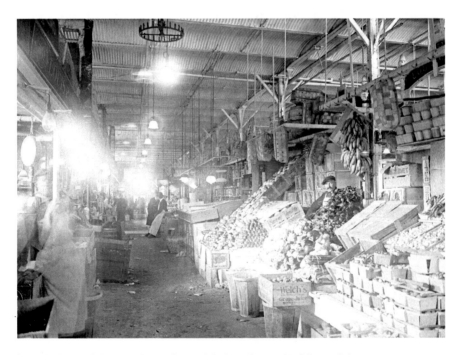

Louis P. Gatti's fruit stand inside Center Market, circa 1922. *Library of Congress.*

grocery shopping."[14] A 1948 article further elaborated: "Numbered among their clients were Presidents Taft, Wilson, and Harding, Cabinet officials, diplomats, and official leaders of the day....Mrs. Gatti often reminisced about the time Mrs. William Howard Taft came to her after the President's inauguration, asking if she would take as good care of the White House larder as she had the Taft residence."[15]

Of course, not everyone was as successful as Gatti. The handsome market building designed by Cluss ended up being as overrun as its predecessors with every sort of huckster vying for some small piece of the action. A *Post* article from 1887 reported the complaints of farmers, truckers and "fruit raisers" who rented space behind the market on B Street, where they sold produce directly to customers from their wagons. They complained about unlicensed competitors who "not only sell to our detriment but take possession of the space allowed us for our wagons, so that daily we are obliged to stand in the middle of the street."[16] To add injury to insult, these farmers were also required to pay five or ten cents per day to market policemen, ostensibly to cover the costs of sweeping the sidewalks, but really everybody knew that the policemen were merely pocketing the money. It just wasn't easy trying to make a living as a small-time farmer.

In July 1896, a dozen Greek immigrants were arrested for blocking access to the market with their pushcarts. "Notwithstanding the fines repeatedly imposed upon these vendors, they will insist upon crowding beyond the lines prescribed by the police regulations," the *Post* commented. "They paid no heed to the warning of the police, and would no sooner be driven back on their stand than they were out in the street again."[17] A subsequent notice in October of the same year found the group arrested again for the same violation.

Of note were a number of African Americans selling all manner of foodstuffs in what was likely the only venue available to them at that time: the market curbside, which they could occupy for free as long as they claimed their space before anyone else. In 1892, the *Post* reported on older African Americans who had survived slavery: "Here on every market day year in and year out are to be found the sturdy remnants of the old plantation stock. Nearly all of them own their own little patch of ground, and their stock in trade displayed on an upturned box or barrel consists of what they can raise with the hoe or glean from the wild products of the woods and fields." Among the products on sale were "the first bunches of half-opened arbutus and dog-toothed violets" in early summer, along with "green leeks and little white spring onions and little indigestible bunches of red and white radishes...Later in the season the stands along the south wall bloom out with a wealth of color, golden rod and

crimson dahlias with stiff-leafed zenias and cockscomb and bachelor's button, the latter warranted to keep indefinitely." One could also observe live terrapins "tethered by one leg to one of the rusty nails that protrude from the edge of the soap box which serves the terrapin's owner for a seat."[18]

A *Washington Times* reporter recorded her own interactions at curbside in 1902. "What in the world is this?" she asked. "That's a mud turtle's flipper, caught in the full of the moon." "Is it 5 cents?" "Lord, no. Flippers come high, lady—when they're caught in the full of the moon. That identical flipper is worth all of 15 cents, but you can have it this morning for 10." "And how much for the hare's foot?" "That's a first-class hare's foot, lady. I ain't seen none to beat it nowhere—but I ain't going to tote it back home if you want it bad enough to pay a dime. There ain't no luck to beat a hare's foot—excepting turtle flippers, of course."[19]

After World War I, substantial changes in the food industry began to spell doom for municipal markets like Center Market. Processed foods

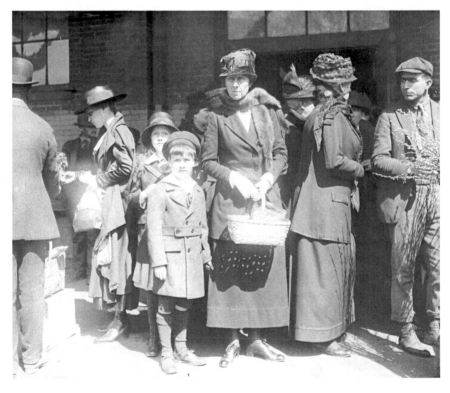

Mrs. David Houston, wife of the secretary of the treasury, and children shopping at Center Market in March 1920. *Library of Congress.*

such as canned and frozen foods, the invention of ever more sophisticated food storage and display fixtures and the rise of local community markets meant that people increasingly no longer needed to come down to the old central marketplace to shop. With the tremendous growth of the city, such a market was increasingly inconvenient. Perhaps most importantly, the grimy, sprawling, red-brick Victorian pile was incompatible with the McMillan Commission's vision of a monumental, white marble city core. As plans developed for constructing the stately, Neoclassical buildings of Federal Triangle, the old market house was doomed.

The market returned to federal government control in 1921, when a law was passed revoking the charter of the Washington Market Company and paving the way for the market's eventual removal. Needless to say, merchants put up a long and hard-fought battle to save it, arguing that George Washington himself had reserved the site for use as a market and thus it had to stay. In the end, the Supreme Court upheld a ruling that the government had legal title to the land and could use it any way it saw fit. Center Market closed its doors for good on January 1, 1931, and was razed over the next several months. A five-foot marble slab, inscribed with the history of the market, was saved from the building's northwest wall, but like many such artifacts, its current location is unknown. More than one hundred merchants chose to move to the Northern Liberty Market at 5th and K Streets, NW, which took on the Center Market moniker for several decades. Other merchants moved to the Western, Arcade, Park View or Riggs Markets or simply went out of business altogether. Today, Eastern Market on Capitol Hill, also designed by Adolf Cluss, is the only remaining public market house in the city. Having recovered from a catastrophic fire in 2007, it continues to prosper.

ALFRED MULLETT AND THE CENTRAL NATIONAL BANK BUILDING

The lots across Pennsylvania Avenue from Center Market were naturally prime real estate with all the traffic that was drawn to this area. Since the late nineteenth century, the Central National Bank Building, on the northeast corner of Pennsylvania Avenue and 7th Street, has presided over the comings and goings with dignity and aplomb. The building dates to circa 1860, when it was built as a five-story Renaissance Revival hotel, one of the largest in the city at the time. The hotel was originally called Seaton House and then was

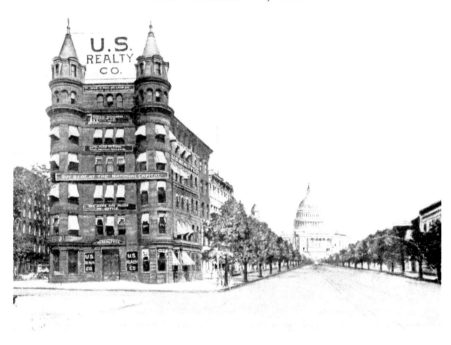

The Central National Bank Building is shown looming over Pennsylvania Avenue in this circa 1908 postcard. *Author's collection.*

renamed the St. Marc in 1871. In 1887, the Central National Bank bought the building for $105,000 and commissioned architect Alfred Bult Mullett (1834–1890) to renovate it for banking purposes. The bank's officers clearly wanted a distinctive new look that would appropriately call attention to their institution. Mullett, perhaps Washington's most prominent architect at the time, responded with a striking brownstone façade and the two distinctive towers that continue to draw attention to the building to this day.

Mullett was an interesting and rather controversial figure. His architectural training seemed inauspicious. He started as an apprentice in the Cincinnati, Ohio office of architect Isaiah Rogers (1800–1869) and, after serving in the Union army, came to Washington to work under Rogers in the office of the supervising architect of the Treasury Department. After Rogers left in 1865, Mullett was promoted to supervising architect, an enormously powerful position that essentially gave him primary control over all major federal building projects in the postwar years. While practicing several styles, he favored the grand Second Empire vocabulary and is perhaps best known for his State, War and Navy Building (now called the Eisenhower Executive Office Building) next to the White House. That building is certainly one

of the most exuberant gingerbread confections to be found anywhere in the country, a building so ornately decorated you have to admire its sheer, unbridled extravagance. Mullett also designed a number of other large, similarly ornate public buildings in cities throughout the United States.[20]

Inevitably, objections arose about the expense of all these structures. Mullett was accused of unnecessary extravagance, and at one point his mental stability was questioned. Having a rather volatile temperament, Mullett didn't take all of this flack easily, and he resigned as supervising architect in December 1874. Despite his considerable architectural talents, Mullett seems to have had trouble getting along with people and was a popular political target. The *New York Sun* reportedly called him "the most arrogant, pretentious, and preposterous little humbug in the United States." Despite these problems, Mullett took up private practice as an architect in Washington after leaving the government, designing about forty buildings during a booming period of the city's growth, of which only a handful are still around. One of them is the Central National Bank Building.

Mullett lived in a mansion on the northwest corner of 25th Street and Pennsylvania Avenue, NW, in the West End. One of his ventures in 1889 was the construction of three row houses (still standing) at the other end of the same block, which he hoped would provide income for his wife, Pearl Pacific Myrick Mullett. However, by 1890, Mullett was in financial straits, partly because he couldn't sell these speculative investment houses and partly because he had lost a court claim for his fees for designing the State, War and Navy Building. Furthermore, health problems were plaguing both his wife and himself. One day in October 1890, Mullett came home from work at 3:30 p.m. feeling "brighter and in better health than [he had] in many days," according to the account in the *Washington Post*, but later that afternoon his attitude changed:

> *He at this time complained of being tired and drowsy, and said to Mrs. Mullett that he would retire for a nap. Mrs. Mullett and their eldest daughter, Miss Josie, accompanied him upstairs to his room. He expressed his desire for a little beef tea, and Mrs. Mullett went downstairs to prepare it for him, the daughter remaining in an adjacent apartment.*
>
> *Almost before Mrs. Mullett reached the lower floor a sharp shot rang out in the bedchamber, startling the entire household. Hastily going to the chamber door they saw Mr. Mullett lying on the floor gasping for breath and the blood oozing from a wound in his forehead.[21]*

Despite his own life being tragically cut short, some of Mullett's great architectural achievements have lived on for more than a century. The Central National Bank, however, remained in its Mullett-designed building only until 1907, when it merged with the National Bank of Washington, which consolidated all of its operations in its own adjacent Romanesque Revival building, constructed in 1889.

The Mullett building was then leased to a variety of grocers, drugstores, lunchrooms and at least one real estate business. A large metal frame for lighted electric signs was erected between the two turrets, as seen in postcard view here.

The building was sold in the 1940s, and the Apex Liquor Store began a large and thriving business that lasted on this site until 1983. In those days, many people knew the building as the Apex Building because of the liquor

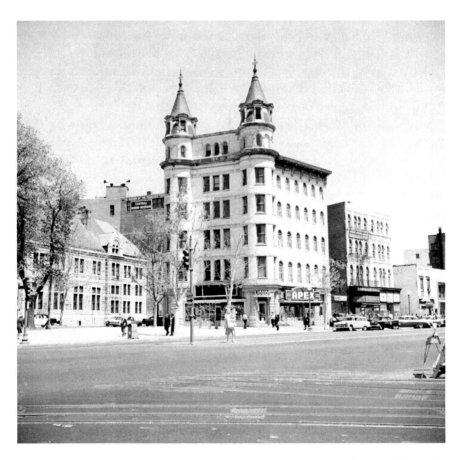

The Central National Bank Building, much deteriorated, as it appeared in 1963. *Library of Congress, Historic American Buildings Survey.*

store there, which also gave knowing Washingtonians a good chuckle, since the Temperance Fountain, erected in 1882, was (and still is) situated just in the plaza outside its front entrance.[22]

After weathering the long decline of downtown Washington, the Apex Building was renovated in 1984 by Sears, Roebuck and Company as headquarters for its Sears World Trade arm. Sears added a story on top of the building but otherwise generally restored the exterior to its original appearance, with the exception that it decided to paint the brownstone an odd mocha color that it still retains today. Sears stayed in the building for less than a decade, and now it is the headquarters of the National Council of Negro Women, Inc.

THE LUXURIOUS RALEIGH HOTEL

Along with the Willard—which is so similar in appearance that many people confuse the two—the Raleigh was one of the largest and grandest hotels in Washington in the first part of the twentieth century. It had a commanding presence on Pennsylvania Avenue across from the Old Post Office Building and was famous as a mecca for patrons of the performing arts. Its loss in 1964 was as devastating culturally as it was architecturally.

The site of the Raleigh had previously been occupied by the Kirkwood House, a hotel famous as the place where Vice President Andrew Johnson was staying on the night of April 14, 1865, and where he was supposed to be assassinated by George Atzerodt. Atzerodt instead got drunk and let Johnson live on to assume the presidency.

In 1875, the Kirkwood was replaced by the Shepherd Centennial Building, an elaborate Second Empire–style structure, which housed the U.S. Pension Bureau and, later, the Palais Royal department store. At seven stories, this thoroughly modern and elegant building was renovated in 1893–94, under the auspices of Washington architect Leon E. Dessez (1858–1918), to become the first incarnation of the Raleigh Hotel.

The Raleigh was an immediate success, and the owners soon began a rapid program of expansion. In 1897, three additional floors were added. In 1898, New York architect Henry Janeway Hardenbergh (1847–1918), who would also be responsible for the Willard, designed a major addition just to the north of the original building along 12th Street. This looming, twelve-story Beaux Arts addition, clad in Indiana limestone and "Baltimore high-grade brick," sent the hotel literally soaring to new heights, with views from the

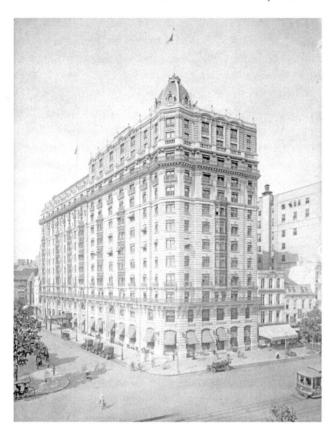

The Raleigh Hotel, circa 1920. *Library of Congress.*

top reaching to Arlington House across the Potomac or out to the Soldiers' Home in the upper northeast. A notable feature of the new addition was its tenth-floor banquet hall, with its high vaulted ceiling; recessed, ornate balcony for orchestral use; and specially monogrammed Havilland china (a boar's head and tobacco leaves, suggestive of Sir Walter Raleigh).

In 1911, the original Centennial building was torn down, and in its place Hardenbergh's looming addition was expanded to create a magnificent, thirteen-story hotel directly on the avenue. Congress was pressed to change the height limit from 130 feet to 160 feet on Pennsylvania Avenue to accommodate this soaring structure. Unlike the Willard with its mansard roof, Hardenbergh's Raleigh had a flat roof, allowing for a luxurious garden with a spectacular view of the city. An octagonal Beaux Arts dome on the corner, tiers of balconies at the third, eleventh and twelfth floors and rusticated details over the entire surface gave the building a grand and imposing appearance.

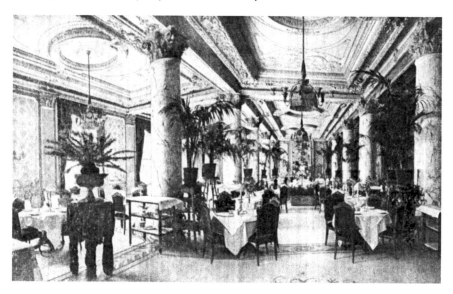

Postcard view of the ornate dining room of the Raleigh Hotel, circa 1914. *Author's collection.*

The Gilded Age exuberance of the Raleigh brought prosperity for its owners well into the 1920s. The Raleigh was the height of fashion, and powerful Washingtonians such as "Uncle Joe" Cannon, Mark Hanna and Champ Clark all were known to down gin rickeys and mint juleps at the hotel's great mahogany bar, with its elaborate iron grillwork and brass rail. Finally, however, competition from the more modern and fashionable Mayflower Hotel began to take business away.

All hotels must fight a constant battle to appeal to the tastes of the moment, and by the 1930s, the Raleigh was overdue for a makeover. A first stab at redoing the place was made in 1931, when modern elevators were installed and the lobby furnishings updated. It was at this time that the venerable old mahogany bar—the last one remaining in a working hotel from the days before prohibition—was converted into a soda fountain.

The real change—the second life, as it were—for the Raleigh came with the hiring in 1936 of Curt Schiffeler (1892–1969) as the hotel's manager, a highly skilled host who had learned his trade in Lorraine, France. Colonel Schiffeler, as he was known to all, almost single-handedly turned the hotel around. He first arranged for a real makeover of the place, at a cost of $250,000. A streamlined, Art Moderne look was the new watchword. Wallpaper in hallways was taken down and replaced with a simple light-toned paint scheme. "Semi-indirect" lighting fixtures created a subtler, sleeker look, accented by "flesh-tinted" mirrors.

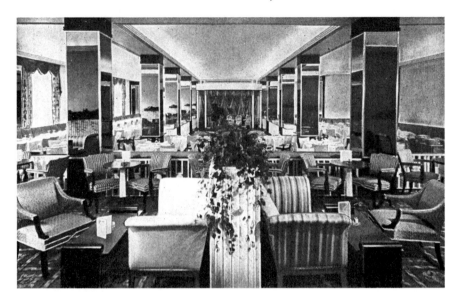

Postcard view of the remodeled Pall Mall Room, circa 1937. *Author's collection.*

The pièce-de-résistance of all of Schiffeler's reinvention was the hotel's dining room, christened the Pall Mall Room, which upon opening in November 1936 quickly became one of the city's top night spots. The streamlined room featured soft rose and chromium hues carried out in window draperies, wall banquettes and columns with gun-metal mirrors and ebony bases. The floor was arranged in three terraces: one level with the dance floor, one arranged with black-and-white tables for dinner parties and a third for the cocktail lounge. Opening night featured Eddie Elkins and his orchestra, "known to radio audiences the country over" for "sweet, swing and hot tunes," complemented by the Don Loper and Beth Hayes dance team from Radio City Music Hall.[23]

The hotel became an immensely popular entertainment venue, and not just because of the fashionable decor. Schiffeler had a special genius for attracting artists, especially writers and musicians, and he began naming suites for special guests, such as Thornton Wilder, Eugene Ormandy, Lily Pons and Sergei Rachmaninoff. Schiffeler made sure that there was always something going on at the Raleigh to create an air of excitement. The Pall Mall Room featured theme nights such as "Argentina," "Old Vienna" or, beginning in 1938, a special annual "Hunt Dinner," featuring the best New Hampshire venison in either a grand veneur sauce or a ragout with currant jelly and puree of fresh chestnuts. This last event was by invitation only to

Washington's two hundred most important guests, which only enhanced the Raleigh's exotic allure.

Schiffeler knew just the right tone to set. He was shrewd enough to invite musically inclined local debutantes to sing along with the name-brand bands he hired for the Pall Mall Room, thus ensuring a loyal and enthusiastic local following. Culturally speaking, Washington was still growing up in the 1940s and 1950s. Although provincialism was waning, a true cosmopolitan sophistication had not yet firmly taken hold. The *Evening Star* observed in 1969 that "there was about the Raleigh as a cultural center an aging, diffident elegance; a seedy grandeur even."[24] It was like no other place.

Things started to go downhill when Schiffeler resigned in 1954 because of disagreements with the hotel's new owners, the Massaglia chain, over policies about employees (the payroll had been cut by 40 percent) and service to guests. With Schiffeler gone and his impeccable service eviscerated, the hotel floundered. In early 1962, it was sold to new owners, who at first said that they would renovate the hotel once again into a plush high-end destination.

Unfortunately, that didn't happen. Instead, the hotel was closed in 1963. The chief excitement at this point was the auction of the hotel's furnishings, held over three days in December 1963. Everything from bathmats to bed linens was sold off. The owner of the nearby Black Steer Restaurant bought the old mahogany bar and all of the other fixtures associated with it for $5,300. Someone else bought the hotel's barbershop for just $375—but, of course, it wasn't mahogany. The building itself was razed in 1964 and was eventually replaced with a nondescript contemporary office building.

FRANK MUNSEY AND THE *WASHINGTON TIMES*

Continuing west on Pennsylvania Avenue from 12th Street, one would soon reach an open space created by E Street merging in on the right. It was made into Freedom Plaza in the 1980s. One hundred years ago, this was Rum Row, and it was the strategic spot that Frank Munsey chose to build his Washington offices.

Frank Munsey (1854–1925) was a Gilded Age capitalist—a robber baron, if you will—who had a major influence on the publishing business at the beginning of the twentieth century. He is credited with perfecting printing processes that could use extremely low-quality "pulp" paper to produce periodicals that were both dirt-cheap and filled with enough racy fare to be widely popular. Thus was born the era of pulp fiction.

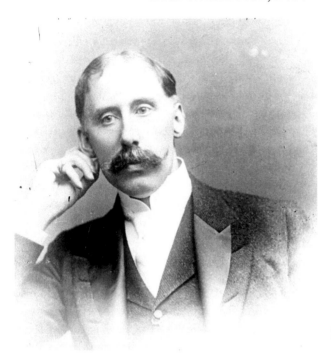

Frank Munsey, circa 1910. *Library of Congress.*

Munsey went on to buy, sell and merge newspaper businesses throughout the country, always for his own profit but often at the expense of the publication's very existence. While others sought journalistic excellence, Munsey seemed cold and ruthless in his push for commercial and financial power, and few mourned his passing in 1925. Renowned newspaper editor William Allen White (1868–1944) wrote:

> *Frank Munsey, the great publisher, is dead.*
> *Frank Munsey contributed to the journalism of his day the talent of a meat packer, the morals of a money changer and the manners of an undertaker. He and his kind have about succeeded in transforming a once-noble profession into an 8 per cent security.*
> *May he rest in trust.*[25]

One of Munsey's many newspaper acquisitions was the *Washington Times*, founded by William Randolph Hearst in 1896 and acquired by Munsey in 1901. (There is no connection between the original *Times* and the current newspaper of the same name, which began in 1982.) In 1905, Munsey bought the old Lawrence Hotel at 1329 E Street, NW, for $120,000, demolished it

and built a grand new skyscraper of an office building in its place to provide permanent quarters for his Washington newspaper. The structures on this block essentially faced Pennsylvania Avenue at that time. The new Munsey Building was just a few doors down from the Richardsonian Romanesque *Washington Post* building and a couple of blocks west of the *Evening Star* building, so all of the important journalists of the early 1900s were in proximity in an area that came to be known as "Newspaper Row."

The original building of 1905 had an ornate façade, which was redone and simplified sometime between 1910 and 1915. In 1915, an addition was built that more or less doubled the size of the building, extending it all the way to the gable-roofed *Washington Post* building to the west. By that time, Munsey had established a bank in D.C., the Munsey Trust Company, and the bank occupied half of the enlarged building, while the newspaper business filled the other half.

The Munsey Building was unquestionably meant to be a prestige office building, and Munsey spared no expense in attaining that goal. He owned a string of newspapers in all of the important East Coast cities—Boston, New York, Philadelphia, Baltimore and Washington—which he envisioned as elements of a great newspaper trust, like Standard Oil or U.S. Steel. This publishing empire needed a ceremonial seat, and the Pennsylvania Avenue building would be the perfect fit. He hired the premier architectural firm of that era, McKim,

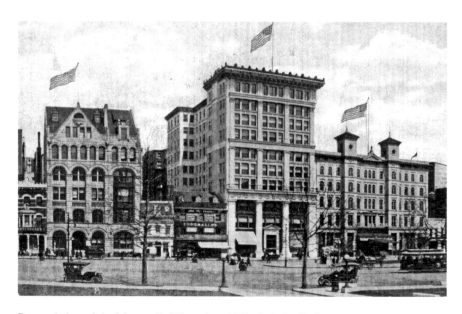

Postcard view of the Munsey Building, circa 1910. *Author's collection.*

Mead and White of New York City, to design the elegant twelve-story Italian Renaissance Revival structure using the highest-quality materials throughout, creating one of the finest private office buildings of its day. The interior banking room on the first floor had marble-paneled walls punctuated by marble Roman Doric pilasters and luxurious marble, wood and brass detailing. The upper corridors had black and red marble bands in the floor design marking the entrances to offices. Even the restrooms had marble wainscoting.

Munsey had a massive executive suite built for himself across the entire front of the top floor, the size more of a ballroom than an office suite, paneled in expensive exotic wood with an ornate fireplace, parquet floors and expensive fixtures. Since Munsey kept his regular offices in New York, this throne room was kept locked most of the time, waiting for the time when Munsey should take up residence in the city. He never did, and after some years the room was dismantled, partitioned and rented out as office space.[26]

The Munsey Building survived for many years, becoming the home to a variety of business and government offices seeking a strategic location

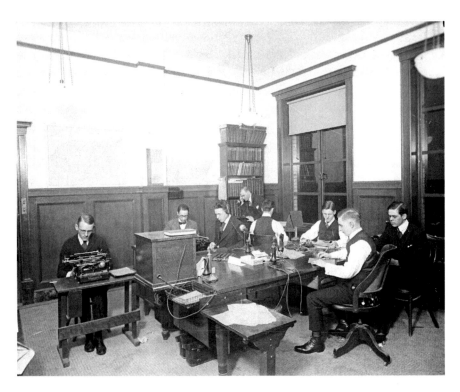

Reporters at work in the Munsey Building, early 1900s. *Library of Congress.*

on Pennsylvania Avenue, including a variety of patent attorneys and political offices. The National American Woman Suffrage Association was headquartered there for a few years in the 1910s, and decades later, Lyndon B. Johnson had offices in the Munsey as he built his power base in the U.S. Senate. The Munsey Trust Company kept its offices there well into the 1950s, although the *Washington Times* had been merged with the *Washington Herald* in 1939 and left the building soon thereafter. In the 1970s, the D.C. government rented much of the space for a variety of municipal departments.

What happened to this venerable building? The Pennsylvania Avenue Development Corporation (PADC), chartered by Congress in 1972 to redevelop Pennsylvania Avenue, essentially damned the entire block where the Munsey stood with the statement that "[t]here are few structures of landmark quality in this square." The Munsey Building itself was dismissed as a "well-defined, early 20th Century commercial building" that was "somewhat outdated by competitive standards."[27] In 1979, the PADC bought the then vacant building with the intention of demolishing it to facilitate construction of a new hotel and office complex.

The move met with significant opposition. The courts temporarily blocked demolition, while lawyers for Don't Tear It Down, the predecessor of the D.C. Preservation League, tried desperately to save the Munsey. The PADC essentially argued that it had special status and powers to do anything that was consistent with its approved plan for Pennsylvania Avenue, and the courts ruled that its actions didn't conflict with the Historic Preservation Act. The demolition proceeded.

In 1979, historic preservation and reuse downtown were not yet well established, and many still worried about when or how downtown would be revitalized. Perhaps, then, it was just lack of faith—or imagination—as to the true potential of a historic structure like the Munsey. In hindsight, we probably can agree that a sensitive restoration and reuse of the Munsey would have been a far better amenity for Pennsylvania Avenue than the bland J.W. Marriott Hotel building that sits there today.

FAST FOOD AT CHILDS RESTAURANTS

Since the late nineteenth century, casual restaurants, or "lunchrooms," have been a staple of commercial downtown areas throughout the country. Long before McDonald's or Wendy's or Burger King, these restaurants were drawing people in with low prices and speedy service. One of the most

successful was Childs, an early twentieth-century chain of lunchrooms that started in New York City and eventually spread nationwide. There were at least three Childs restaurants in Washington, including on Pennsylvania Avenue and Massachusetts Avenue, NW.

Samuel (1863–1925) and William (1866–1938) Childs, two brothers from New Jersey, opened their first restaurant in New York City in 1889, a time when casual consumption of food at lunch counters was just beginning to become popular. As described by Virginia Kurshan in a 2003 landmark application for a New York building, the Childs brothers capitalized on a few simple ideas. They conveyed a sense of cleanliness by using white-tiled walls and floors, white marble tabletops and waitresses dressed in starched white uniforms. Their restaurants were designed in an "austerely elegant" style, with bentwood furniture, mirrors and exposed ceiling fans "to complement and also to represent the simplicity and purity of the food," according to Kurshan. Childs emphasized fast service and made money by turning over tables quickly, in part because the hard surfaces discouraged people from lingering. Another signature feature of early Childs restaurants was a chef in the front window preparing flapjacks to catch the attention of passersby.[28]

Washington Post commentator H.I. Phillips summed up the style of these restaurants with characteristic wit in 1929:

> *The early Childs restaurants were so glaringly white it didn't seem right to enter them without a bath, shave and haircut. They were architecturally part laboratory, part squash court, part Roman pool, and part goldfish bowl.*
>
> *Then the owners dressed their managers like hospital internes, put their waitresses into attire partly suggestive of child brides and partly suggestive of dentists' assistants, developed tray-dropping to a high art and prospered.*
>
> *Speed was the keynote. Buttered toast set new heights in rapid transit, and all previous records held by eggs in flight between kettle and customer were broken.*[29]

The first Washington Childs was located at 1423 Pennsylvania Avenue, NW, just west of the Willard Hotel and a block east of the Munsey building. It was designed by company architect John Corley Westervelt (1873–1934) in 1913 and built for $75,000. Seating two hundred, it conformed to all of the classic Childs parameters, including the white-tiled interior and the flapjack flippers in the front window.

Like any good restaurant, it rarely made news. In October 1918, a minor tiff developed between Childs and the D.C. food commissioner when

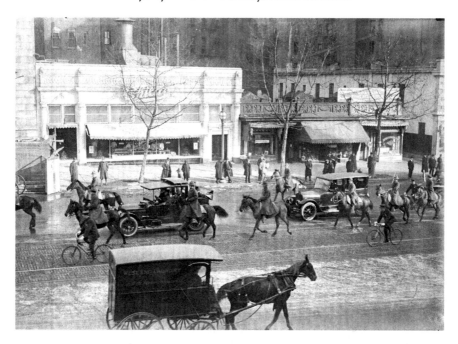

The Pennsylvania Avenue Childs, seen in 1917 as a diplomatic motorcade passed in front. *Library of Congress.*

Childs raised its prices, contrary to the food commission's guidelines. Childs eventually agreed to follow the D.C. wartime guidelines, which specified precise menu options at fixed prices, according to the *Washington Times.* For breakfast, among other options, one could order prunes, cereal, toast and coffee for thirty cents. Lunch was cheaper: a sandwich—ham, tongue, cheese, salmon or egg—ran just ten cents.[30]

The second Childs was located at 2 Massachusetts Avenue, just a block west of Union Station; it was completed in 1926. By then, competition was forcing the Childs chain to evolve. The company had always made sure that it constructed distinctive, quality buildings for its restaurants, places that would seem special to the common folk who were expected to dine there. But the white-tiled look was getting to be old-fashioned; it looked too much like what it was, a lunchroom. About this time, William Childs hired the brilliant modernist architect William Van Alen (1882–1954) to design a number of restaurants in the Childs chain. Van Alen would go on in 1929 to design New York City's Chrysler Building, perhaps the ultimate Art Deco celebration of modernism in American architecture.

Interior of the Childs Restaurant on Pennsylvania Avenue, circa 1920. *Library of Congress.*

Before working on the Chrysler Building, Van Alen designed the Massachusetts Avenue Childs restaurant—one of his few works, or maybe his only work, in Washington. It, too, was clearly meant to be distinctive, and Van Alen knew that this is what his clients wanted. A *Post* article that appeared at the time of its opening raved that there was "a lofty dignity and an architectural beauty about it seldom seen in restaurants. It is the type of building Washington needs to make it the city of beauty."[31] A much later article reported that the Childs company "leased property as near as possible to Union Station so 'travelers coming to Washington will see the name Childs in lights as soon as they step off the train.'"[32] While that goal may have been overly ambitious, the restaurant surely must have beckoned travelers as they came out to Massachusetts Avenue, its huge, brightly lit windows sending a message of warmth on cold winter evenings.

The building's exterior is finished in an exotic, rarely seen stone. According to the *Post* article, it was one of only two buildings in the United States made of "Italian Doria limestone, a lava rock from Italy." Christopher Barr has

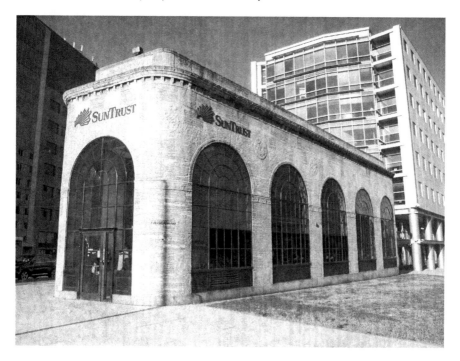

The Childs Restaurant at 2 Massachusetts Avenue, NW, is now a SunTrust Bank. *Photo by the author.*

studied this stone in detail and discusses it on his excellent website, Fossils in the Architecture of Washington, D.C. Barr questions what type of stone it is. It is very soft and now highly eroded, with ancient marine fossils very clearly embedded in it, negating the possibility that it is volcanic.[33] Round decorative medallions, now largely worn away, are carved on the upper part of the walls between the great bronze-framed windows, which were made in Rhode Island.

Inside, the walls were clad in expensive Italian travertine. The color scheme, as the *Post* pointed out, was a radical departure from Childs' white-tiled past. The ceiling was painted a robin's egg blue, contrasting pleasantly with the buff color of the limestone walls. Indirect lighting was provided by fixtures concealed around the edges of the ceiling. Travertine columns along the walls were topped with hand-carved scrolls, while wainscoting was of Hauteville marble. The floor was inlaid with Sienna, Cardiff green, Vermont white and black Belge marbles. The entire one-story structure served as the dining room, so that one was left wondering where the food

was cooked. In fact, a large basement was built underneath, extending out much farther than the walls of the ground floor. In addition to the kitchen, storage rooms, washrooms, employee lockers and so on, there was also room for a cafeteria, although it may never have been used as such. All of that imported marble and those bronze fittings made the restaurant expensive to build, at $175,000, but it demonstrated the company's determination to create a monumental eatery.

The late 1920s and early 1930s brought more change to the Childs chain. William Childs, who took over after brother Samuel died in 1925, was an avowed vegetarian and decided to adopt a purely vegetarian menu for the chain, to the dismay of customers and stockholders alike. He also instituted a policy of charging for glasses of water, an equally unpopular move. William was finally forced out in 1929, and the company soon brought back meat and free water.

The *Post* reported in January 1935 that the chain was redecorating its restaurants according to a variety of different themes. The Pennsylvania Avenue eatery went "Mexican, with adobe, irregular walls, iron railings, scenic paintings, Mexican posters and a hostess resplendent in ruffles and roses behind her ear." Also mentioned was the branch located at 1340 New York Avenue, NW, which was taking on a neocolonial look, "with paneled walls, wide boards in the floors, antique lighting fixtures and a hostess in hoop skirt."[34] The Massachusetts Avenue location is not mentioned and was presumably already classy enough to keep up a strong clientele. A later *Post* article noted that it was at one time a fashionable eating place for late theatergoers and moviegoers.

In February 1949, the Legislative Assembly and Rally to End Segregation and Discrimination was held in Washington, attracting civil rights leaders from around the country, including W.E.B. Du Bois and former vice president Henry A. Wallace. On the afternoon of February 13, a group of about eighty attendees at the rally, "members of New York and other out-of-town delegations," according to the *Post*, descended on the Massachusetts Avenue Childs and sat at most of its tables, demanding to be served.

This was apparently a very peaceful protest. The participants were not served, and they left after about three hours. But their demonstration was not in vain. Equal access to restaurant facilities became an important demand of the civil rights movement. The following year, Washington activist Mary Church Terrell (1863–1954), along with three other African American leaders, walked into a Thompson's restaurant, put soup on their trays and sat down to eat. They were asked to leave. A lawsuit was promptly filed on their

behalf, and it finally led to a court ruling in 1953 that segregated eating places in Washington, D.C., were unconstitutional. Thompson's was a Chicago-based chain and the main rival of Childs; its downtown D.C. cafeteria, now long gone, was located on the southeast corner of 14th Street and New York Avenue, NW, only a few doors down from the New York Avenue Childs.

By the mid-1950s, the Childs chain was beginning to run out of steam. Its owners were occupied with developing and operating hotels and had allowed the chain to languish. The Pennsylvania Avenue branch shut down about 1950 and was demolished to make way for a parking lot.

Childs backed out of its lease on the Massachusetts Avenue location in 1955, closing the restaurant (its last in D.C.) after almost thirty years. The building was bought by the R.A. Humphries and Sons real estate firm for $100,000, only a little more than half what it had cost to build in 1926. Humphries was there until 1969, when the building was sold to the Catholic War Veterans of the United States, which found it quite suitable as a war memorial, adorning the stately travertine walls with long lists of veterans' names. By 1987, that organization, too, was gone, to be replaced by a Popeye's restaurant. SunTrust Bank is the latest tenant.

The structure remains a unique architectural memento from the past. Its primary enemy at this point is probably the weather, which is slowly but inexorably eating away at its exotic stone façade.

BASSIN'S RESTAURANT: WASHINGTON'S FIRST SIDEWALK CAFÉ

A block away from the Pennsylvania Avenue Childs, a modest, four-story storefront once stood, the site of Washington's first sidewalk café. The little building, constructed in about 1872, saw much in the way of what Washington had to offer for nighttime entertainment. Its classic Italianate façade of pressed brick with ornamental cast-iron window hoods and sills gave no hint of its long career of gambling and booze.

The building was located on the same stretch of E Street (facing Pennsylvania Avenue between 13th and 14th Streets, NW) as the Munsey Building a few doors to the east. The street had been known since the mid-nineteenth century as "Rum Row" for its drinking and gambling dens, and this building had one of the worst. According to journalist George Rothwell Brown, the bottom floor was occupied by John Lawrence Kidwell's drugstore, a respectable business with marble floors and beautifully carved mahogany

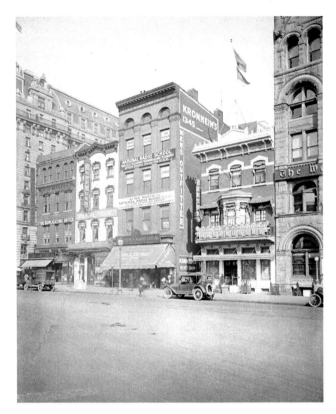

A sign for the Chop
Suey Restaurant is
prominent on the
white building in this
circa 1920 photo.
The building would
later become home to
Bassin's Restaurant.
Library of Congress.

woodwork. But upstairs was the celebrated gambling house of George Parker, where the "best known faro bank in town" operated. "A Chinese restaurant now serves chop suey in the rooms which in the hectic past were dedicated to the Goddess of Fortune and which echoed to the whir of the roulette wheel and the click of dice," wrote Brown in the *Washington Post* in 1923.[35] By 1887, a tobacconist by the name of Daniel Loughran had moved into the respectable ground floor; he and his sons ran their business there until 1929.

Over the next ten years, an assortment of commercial enterprises came and went, including offices of the *New York World* and the National Press Club and what Brown called "various drinking clubs" until 1939, when Max Bassin (1911–1977) opened his restaurant there. Born in New York, Bassin had moved to D.C. as a child and attended Cardozo (Business) High School. He had worked at the Treasury Department but decided to quit and start Bassin's Restaurant instead. He went in on it with his wife, Sarah (1911–2010), and her brother, Harry Zitelman (1913–2007). Bassin's was a rather ordinary lunchroom-style restaurant for many years, concentrating on selling

corned beef sandwiches for twenty-five cents and hot dogs for a dime. Then, in 1949, Bassin decided to quit the business and devote his attention to real estate. He left the restaurant in the hands of his sister and Harry Zitelman.

Zitelman, who was the son of Russian immigrants and had grown up in Baltimore, capitalized on Bassin's prime location near the National and Warner Theaters, various newspaper offices, the Willard Hotel and the District Building. As time went on, Zitelman built Bassin's up until it was a well-known Washington institution. He expanded into the building on the corner, making Bassin's a sprawling complex that was frequented by both tourists and natives alike. And like all top-drawer restaurateurs, Harry Zitelman was a consummate showman. He didn't just work hard to promote Bassin's; he made sure that everybody knew he was doing it.

As reported in the *Washington Post*, Harry Zitelman and Jean Moran of L'Espionage at 2900 M Street, NW, sought permission in early 1959 from the District's board of commissioners to set up sidewalk cafés. The request was not well received. One concern was a 1934 law that banned consumption of alcoholic beverages on District sidewalks—it was not clear that serving any

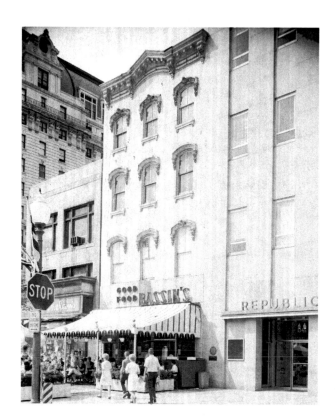

Bassin's Restaurant in 1967. *Historic American Buildings Survey, Library of Congress.*

kind of food or beverages would be legal under that law. Opinions about the proposal touched on many other issues as well. The *Post* talked to Leonard Carmichael (1898–1973), secretary of the Smithsonian, who said that he had "enjoyed looking at sidewalk cafés in Spain and Rome, but I'm not sure I would enjoy them in Washington." Why not? He apparently didn't say. Prominent socialite Gwendolyn Cafritz (1910–1988), known for her "Gwendolynisms," held that "Washington is just perfect the way it is. I don't think the tempo of Washington is suited to sidewalk cafés. Nobody would have time to sit in them."[36]

These were just the opening salvos in the two-year struggle to bring sidewalk dining to Washington. While Moran seems to have dropped out of the fight, Zitelman kept pushing. In late 1960, a ruling came down denying Zitelman's request on the grounds that alcoholic beverages couldn't be served on the sidewalk. Zitelman responded by asking for a permit to open his sidewalk eatery without the alcohol. At a March 1961 hearing before the board of commissioners, Zitelman presented a stylish, Parisian-looking sketch of how his proposed sidewalk café might look. But not all hearts and minds were won.

As reported in the *Post* on March 17, 1961, an assortment of D.C. government witnesses outlined a litany of perils that would befall the hapless citizenry if sidewalk cafés were allowed in the District. These hazards included the following:

- Pedestrian traffic would be disrupted. People would be forced to walk in the streets and probably get run over.
- Food would be exposed to dust, dirt and "windblown foreign matter," creating a health hazard.
- Hungry birds, insects and rodents—especially squirrels—would discomfit patrons, and the city's rodent control problem would be "multiplied many times."
- Chairs and tables would interfere with the laying of hoses during a fire.
- Street litter would be exacerbated.
- Street-spraying trucks might splash water over the curbs and onto customers.
- It would be harder to do utility work, which might require tearing up the sidewalks.
- The cafés would be a "potential source of disorder" because patrons might brush against sidewalk pedestrians, possibly leading to fisticuffs and so on.

- Passersby might steal pocketbooks or other valuables from patrons.
- And finally, according to Deputy Police Chief Howard V. Covell, "this type of operation would provide a favorable setting for ladies of easy virtue as they ply their trade up and down the street."

After all that, according to the *Post*, Chief Commissioner Walter N. Tobriner observed that he "couldn't understand how, with all the calamitous eventualities foreseen by city officialdom Europeans have been able to operate sidewalk cafés all these years." Concluding that "anything which would enhance the innocent enjoyment of Washington…should be allowed," Tobriner then ordered that regulations be drawn up that would allow sidewalk cafés while affording adequate safety.[37]

The Sidewalk At Bassin's opened with much fanfare in August 1961 and was an instant success. Zitelman found his overall business up 15 percent. Still, there were complaints that the café should serve "something beside malts," so Zitelman worked to get the alcoholic beverage ban lifted, which he achieved the following year. In 1962, Washington's second sidewalk café

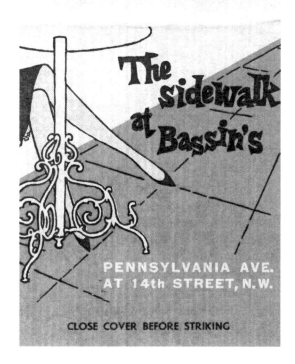

Matchbook cover promoting Bassin's sidewalk café. *Author's collection.*

was opened at Chez François on Connecticut Avenue, NW. By 1963, some twenty different restaurants had joined in, and the sidewalk café had become an established part of D.C. culture.

The sidewalk café wasn't Zitelman's only innovation at the Bassin's complex. In 1962, he opened one of the city's first discotheques, called the Top O' the Walk Twist Room, in the former Atlas Club upstairs from the dining room. According to the *Post*, Zitelman got the idea after seeing Chubby Checker dancing the twist in New York. The *Post*'s arts commentator, John Pagones, visited in April 1962 and was very enthusiastic: "The Fred Astaire dancers give twist lessons every night but it seems like bringing politics into Washington. Those people can really twist. The supply seems bottomless." Ranging about Bassin's, Pagones noted that in addition to the dining room and cafeteria, there was also a lounge where "Jerry White knocks the daylight out of a piano with his honky-tonk songs," as well as a "noisy, chummy rathskellar" in the basement called L'Escapade Room.[38] These were Bassin's salad days, so to speak, and unfortunately there would not be many more of them.

Bassin's was picketed in the mid-1960s for its hiring practices. It was accused of keeping most African American employees in the kitchen and using mostly whites for the "out front" positions, such as waiters and waitresses. Bassin's agreed to hire more equitably, but business began to decline anyway after the April 1968 riots. In 1976, the restaurant was sold to a wealthy South Vietnamese family that had decided to move to Washington and get into an American type of business. Then, after only two years, the restaurant was gutted in a suspicious predawn fire in October 1978. Members of the police arson squad told the *Post* that they were 75 percent sure that the fire was started by igniting a flammable fluid. However, by that time, the building was already slated to be torn down to make way for a massive new hotel/office complex. Within a year, with the blessing of the Pennsylvania Avenue Development Corporation (PADC), the burned-out structure was razed. The J.W. Marriott Hotel now spans this end of the block.

Still, a few shards have survived of this venerable little building that witnessed so much of our local color. In the 200 block of 8th Street, NW, just north of the Navy Memorial on Pennsylvania Avenue, a few of the metal window hoods and sills from Bassin's hang like ghosts over large vents at a Pepco substation. In one of its last acts before being dissolved by Congress in 1996, the PADC worked with Pepco to use façade elements salvaged from a number of razed buildings, including Bassin's, to mask the blank wall of this building. Almost literally shadows of their former selves, the Bassin's window hoods and sills memorialize a place that nearly everyone has forgotten.

Part III
Downtown's Booming Businesses

In the nineteenth century, the city's business district, originally concentrated along Pennsylvania Avenue, gradually expanded along several north–south arteries, including 7th Street, 9th Street and, later, 14th Street. Commerce flourished throughout the downtown area, anchored by key businesses that drew heavy patronage. Beginning in the 1880s, many merchants moved their stores from flood-prone Pennsylvania Avenue to higher ground along F Street, which became the city's main retail drag. On the west end stood the Treasury building, at 15th Street, in a neighborhood of financial institutions and "polite" entertainment. Farther east, at 9th Street, more earthy fare was available, and one's wallet was probably in greater danger. The Woodward & Lothrop department store, another big draw, was in the middle. Perhaps one of the most significant beehives of human activity was the Greyhound bus station, a few blocks to the north at New York Avenue.

"Polite" Vaudeville and Other High Drama on 15TH Street

The southeast corner of 15th and G Streets, NW, directly across the street from the Treasury Department and just a block from the White House, has been a power address since banker George W. Riggs (1813–1881) invested in it in the mid-1800s. Riggs had built the Riggs House hotel, which stood there from 1860 until 1911. But Riggs's heirs decided that they could make

more money by constructing a much larger office building on the site. The new building would house one of the city's grandest theaters, but the real drama would come when preservationists tried to save it from annihilation in 1979.

The new Riggs Building, completed in 1912, was designed by Jules Henri de Sibour (1872–1938), one of Washington's most prominent architects. De Sibour clearly took inspiration from the Beaux Arts–style National Metropolitan Bank Building, completed in 1907, immediately adjoining the Riggs site on 15th Street. He kept the same scale and building materials—including brick faced with white Tennessee marble on the bottom floors and a copper mansard roof with dormers—to form a stately and unified row of buildings that "answered" Robert Mills's imposing Neoclassical Treasury building across the street. Rich classical embellishments are everywhere in the two buildings, yet they are never overdone. The bank building has two great Corinthian columns that convey strength and solidity and yet are set within a marble picture frame, as it were, that keeps them from being overbearing. Both buildings share a heavy modillioned cornice above the sixth floor, topped with lion heads. For the Riggs Building, De Sibour echoed the bank's Corinthian columns with more subtle pilasters and added classical swags and other elegant surface ornamentation.

Inside the Riggs Building, rich Gilded Age decorations abounded. The centerpiece of the building was its great theatrical auditorium,

Postcard view of the Riggs Building, circa 1920. *Author's collection.*

which extended up six stories toward the rear of the building and could accommodate 1,838 patrons in beautiful mahogany seats upholstered in red Spanish leather. The walls were covered with red silk tapestry, and the stage curtain was, of course, ruby red with fringes of gold. The magnificent lobby out front was finished in Siena marble with an allegorical terra-cotta frieze. A distinctive feature was a promenade below the auditorium, finished in old English oak with two libraries (the men's in leather and the ladies' in plush) and two retiring rooms. The basement level also held an elaborate Turkish bath, a large barbershop, some twenty-five dressing rooms and even rooms for stage animals.

The theater was initially leased to Plimpton B. Chase for his Chase's Polite Vaudeville Theatre, which previously had been operating at 1424 Pennsylvania Avenue, NW, in the former Grand Opera House (built in 1884). Chase had been very successful with this "polite" vaudeville, which he described as "a clean and wholesome pleasure for the refined men, women, and children. It is wholly American, and attracts to its theater only the best elements in the community." It had become popular in no small part because

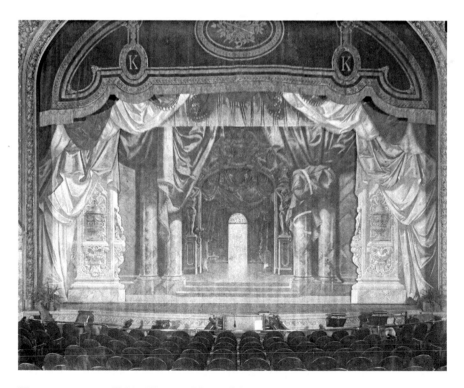

The ornate stage at Keith's Theatre. *Library of Congress.*

57

families could attend without worrying about the risqué content that might be encountered in lower-class burlesque houses. Chase aimed squarely at the pocketbooks of the prosperous upper middle classes.

Chase was only in the new building for a year before he retired and sold his theater to B.F. Keith (1846–1914), the reigning king of vaudeville in the eastern U.S., operating some thirty different theaters and having an estimated net worth of $50 million. Keith had begun in Boston on the same principles as Chase, offering only clean entertainment that would appeal to middle-class sensibilities and eschewing the bawdiness of burlesque houses. With the help of his ruthless manager, E.F. Albee (1857–1930), he became wildly successful. His theaters all reportedly posted backstage the following warning for performers:

> *Don't say "slob" or "son of a gun" or "hully gee" on the stage unless you want to be canceled peremptorily. Do not address anyone in the audience in any manner. If you do not have the ability to entertain Mr. Keith's audience without risk of offending them, do the best you can. Lack of talent will be less open to censure than would be an insult to a patron. If you are in doubt as to the character of your act consult the local manager before you go on stage, for if you are guilty of uttering anything sacrilegious or even suggestive you will be immediately closed and will never again be allowed in a theatre where Mr. Keith is in authority.*

The new B.F. Keith's High-Class Vaudeville Theatre became one of the most prestigious in the Keith's chain. President Taft was at the opening night show in 1912, and Woodrow Wilson rarely missed a Saturday evening show there when he was president. A plaque commemorating Wilson's frequent visits was put up in the theater in 1931. Entertainers included nationally famous performers such as Will Rogers, Eddie Cantor, Rudy Vallée, Laurel and Hardy, ZaSu Pitts and others.

Vaudeville, of course, was eventually eclipsed and then eradicated by the success of the motion picture business. In 1928, Keith's added feature films to its bill of fare and then in 1932 converted to a purely motion picture program, the last theater in Washington to give up on regular vaudeville performances. A series of mergers turned the Keith's chain into the Radio-Keith-Orpheum (RKO) Radio Pictures company, and it showed its premier films at the rechristened RKO Keith's Theatre.

In 1956, RKO sold the Riggs Building, now known as the Keith-Albee Building, to Washington real estate developer Morris Cafritz (1887–1964) for $1.55 million, leasing back the theater to continue showing first-run

films. That led to the first chance the city had (and lost) to save the elegant building for posterity. Cafritz bought it hoping to convert the building back to live stage performances, and in 1959 he offered it to the city for use as a performing arts center after the Sam S. Shubert Theater on 9th Street (originally the Gayety Theater)—the only venue in the city then hosting live performances—had a catastrophic fire and was shut down.[39] However, there were strings attached. Although it was a "gift," the city would have to assume the $1.5 million mortgage on the property as well as pay for its upkeep. There had been lots of talk of trying to get a decent performing arts venue in the city, including embryonic plans for a National Cultural Center in Foggy Bottom, which would eventually become the Kennedy Center for the Performing Arts, but in the end the D.C. commissioners balked at the $1.5 million mortgage and said no thanks to Cafritz.

Things went downhill from there. There was talk as early as 1962 of tearing down the Keith-Albee and all of the other structures on the block to make way for a large new office building, but it didn't happen…yet. The theater continued to show films up into the 1970s, although they were no longer the best titles. Just before it closed in 1978, it was showing the likes of *Twitch of the Death Nerve*, *Fritz the Cat* and *Black Samurai*. That's when developer Oliver T. Carr Jr. stepped in.

After the subway system had opened in 1976, hopes were high that downtown could be revitalized, and developers were beginning to plan ambitious new projects. In November 1977, Carr, a big investor in the old and then run-down part of downtown, announced plans for a $40 million "mall" to cover all of the Keith-Albee's block except for the Garfinckel's store on the 14th Street side. As reported in the *Washington Post*, Carr initially announced that he intended to save Rhodes Tavern, located at the 15th and F Streets corner. The small, dilapidated tavern, built about 1800, was one of the most important buildings connected with the early days of Washington City, as important to its civic and cultural life as Suter's Tavern had been to Georgetown's. It was clearly the most historically significant structure on the block. The Keith-Albee and National Metropolitan Bank buildings, in contrast, were grand and beautiful, but Carr hinted that they might have to go if $5 million couldn't be drummed up to save them.[40]

The ensuing fight over what and how much to save played out at a unique turning point in the city's commitment to historic preservation. All three buildings—the Keith-Albee, National Metropolitan Bank and Rhodes Tavern—had been recently placed on the National Register of Historic Places, but in 1977 this just meant that a developer needed to work with

the local community on ways to save them. Demolition could be delayed somewhat but not banned outright. In February 1978, the *Post* reported on the options that Carr was said to have presented to the community. While he was willing to support historic preservation, he needed $1.5 million to save the Rhodes and $4.7 million to save the façades of the other two buildings. As quoted in the *Post*, Carr said, "We will proceed with total demolition if we can't raise the funds."[41] He filed for a demolition permit to start the clock running on the maximum delay (240 days in this case) that could be imposed before allowing demolition to proceed.

Throughout 1978, efforts were undertaken to find funding to save the historic buildings, but with little success. Meanwhile, largely through the advocacy of Don't Tear It Down, the predecessor of the D.C. Preservation League, the D.C. City Council voted to adopt a new historic preservation law that would require developers to prove economic hardship before being allowed to destroy historic landmarks. But it came too late. In March 1979, Carr received the very last demolition permit issued by the D.C. government on the day before the new law went into effect.

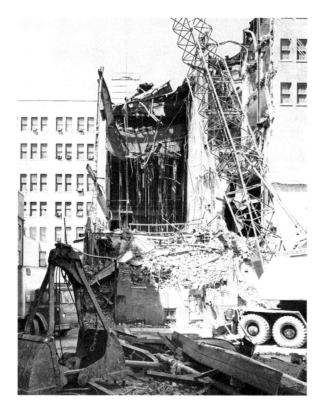

Demolition at the rear of Keith's Theatre in 1979. *Historic American Buildings Survey, Library of Congress.*

Carr began demolition at the rear of the building in early April 1979 and was quickly met with street protests as well as legal action from Don't Tear It Down, which won some temporary delays in the destruction. At one point, Carr was allowed to continue ripping out most of the interior of the Keith-Albee while efforts proceeded to try to find money to save the building's façade. The D.C. government in conjunction with Don't Tear It Down worked hard but could not come up with sufficient funds in the limited time available. First Lady Rosalyn Carter telephoned the mayor to try to help. All was to no avail. In July 1979, the *Post* reported on a final court ruling by Judge William E. Stewart Jr. Noting that "when the government goes into the business world the government has to be able to conform to the business world's needs," the judge ruled that Carr could proceed with demolition because the necessary funds to pay for preservation had not been forthcoming.

At this point, Carr offered a final take-it-or-leave-it deal, according to the *Post*. He would save the façades of the Keith-Albee and National Metropolitan Bank buildings after all, but only if the White House, D.C. government and Don't Tear It Down all agreed to support his complete development plan, which included moving or demolishing the Rhodes Tavern. The agreement was signed. With these power players out of the picture, others took up the cause of saving Rhodes Tavern, and the struggle went on for another four years. There was even a public referendum at one point, with D.C. voters endorsing a resolution to preserve the historic tavern. It wasn't enough. The little building was finally demolished in 1984, and Carr's Metropolitan Square office complex then filled out the block. Meanwhile, the façade of Henri de Sibour's Riggs Building lives on, although it is literally only a shell of its former self. The elegant Beaux Arts theater, which would undoubtedly be prime performing arts space now if it had survived, is just another memory.

THE GAYETY THEATRE: BURLESQUE ON 9ᵀᴴ STREET

In contrast to the "high class" polite vaudeville on 15th Street, a bawdier form of entertainment—burlesque—prospered just a few blocks to the east. One hundred years ago, 9th Street just north of Pennsylvania Avenue was where the real action was. "Ninth Street was the Broadway of Washington," a former fight promoter named Goldie Ahearn recalled years later in the *Washington Post*. "Everything that ever happened in this city happened there. When you came to town you had to strut up and down Ninth Street or you hadn't lived." And in the heart of this mini Times Square was the fabulous

Gayety Theater, where the girls were always kicking their legs up and the comedians gunning for endless, easy laughs.

The Gayety, located at 513 9th Street, NW, was designed by noted theater architect William H. McElfatrick (1854–1922) and completed in 1907 at a cost of about $130,000. Although the building's frontage on 9th Street was only the size of a typical storefront, it masked a sprawling complex that extended back to 8th Street, where a large auditorium was located. The stage was sixty-five feet wide and thirty-four feet deep.

It was a completely over-the-top extravaganza of decorative flourishes, both inside and out. The façade, made of brick and galvanized iron, embodied a lively and eccentric mix of styles. Beaux Arts rusticated piers surmounted by pairs of Corinthian columns held up a massive hooded arch

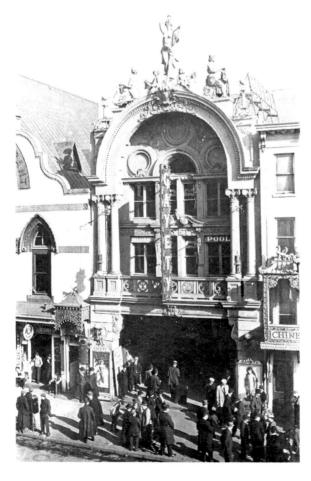

Postcard view of the Gayety Theatre shortly after its construction. *Author's collection.*

topped by a crowded assemblage of gaudy classical figures. A deeply recessed entry drew customers into the building, leading them back to the ornate three-story auditorium, said to be capable of seating 1,500. The original decor was ivory and gold, with "rich Empire red" sidewalls, according to the *Washington Times*, and featured commodious seats and all-unobstructed views. Newspaper accounts boasted that the building was designed using state-of-the-art fireproof techniques. The stage, for example, could be rapidly isolated from the rest of the auditorium with massive sheet-iron doors and an asbestos curtain. All in all, this was a very impressive theater in 1907.

The theater was a member of the Columbia Circuit (eastern "wheel") of burlesque theater owners. There was also a western wheel. The wheels were affiliations of theater venues that provided a full season's bookings for traveling shows. According to Robert C. Allen, by 1912 about seventy touring burlesque companies played at one hundred theaters across the country and employed some five thousand performers.[42]

The early years of the Gayety's existence—the 1910s and 1920s—were undoubtedly its heyday, a time when burlesque was still a going theatrical concern. By the end of the nineteenth century, the theatergoing experience in America had become rigidly stratified. Legitimate theater, as was performed at the National Theater on Pennsylvania Avenue, for example, was for the upper classes, kept safely out of reach of those with insufficient means or taste. Vaudeville—often called "polite" or "high class" vaudeville—was marketed squarely to the middle classes and kept carefully clean and wholesome. The major D.C. vaudeville house, as we have seen, was over in the Riggs Building on 15th Street, NW, a safe and respectable neighborhood. Burlesque filled out the bottom rung of theater's social ladder and found its home in the city's tenderloin district, the hurly-burly world of the 9th Street strip. It was everything vaudeville wasn't: irreverent, iconoclastic, raucous and licentious. Burlesque catered largely to young urban males of the working class with its deliberate skewering of social mores.

When the Gayety opened in 1907, the shows generally consisted of lavishly decorated skits involving a troupe of "soubrettes"—saucy, sexy young coquettes—interacting with a few male comics and straight men in raunchy satires of upper-class lifestyles. Mollie Williams was an example of a popular soubrette known for her racy, wisecracking manner. She was reportedly the only woman with her own traveling burlesque company in the Columbia Circuit in the late 1910s and early 1920s. Among shows she and her troupe played at the Gayety were "The Queen of Bohemia" in January 1914 and "The Unknown Law" in September 1920.

Mollie Williams had a traveling burlesque troupe that played at the Gayety in the 1910s and 1920s. *Author's collection.*

The Columbia Circuit tried to walk the fine line between risqué and rude, but ultimately it was a losing game. By the end of the 1920s, the more prosperous and better-financed vaudeville theaters had already taken away viewers wanting cleaner entertainment, and the burgeoning movie business was now taking customers from both vaudeville and burlesque. The burlesque theaters began to give up on theatrical performances and focus just on the girls. The Columbia Circuit of traveling burlesque companies, after consolidating with other "wheels," folded completely in 1931. Instead of its expensive bookings, theaters like the Gayety began to use "stock" burlesque shows that were much cheaper to produce and mostly consisted of striptease artists.

In January 1929, when it was still primarily a theatrical venue, the Gayety achieved unusual notoriety when it produced a midnight benefit show for the families of four imprisoned gamblers. The four had been thrown in the clink for participating in an illegal blackjack game, and they had all refused to implicate any of their cronies. A local boxing promoter conceived of the idea of a lavish show to benefit the families of the four "who did not squeal," and so it came to pass. A long bill of many acts, mostly performing gratis, played on until nearly dawn to a hall that was packed, despite the fact that all advanced notice had been strictly by word of mouth. The newspapers caught wind of the spectacle, and soon the House Committee on the District of Columbia was holding a hearing on the event, seen as proof of how organized the gambling and bootlegging rackets were in Washington. However, much to everyone's frustration, it was clear that no laws had been broken. Besides, several off-duty policemen were apparently in attendance. It seems the uproar finally blew over when officials lost their appetite for exploring the extent of corruption in the Metropolitan Police Department.

The Gayety always drew its share of Washington's officialdom, including many members of Congress, government officials and even a president or two. Supreme Court justice Oliver Wendell Holmes (1841–1935) was a Sunday afternoon regular, according to the *Post*. The *Washington Times-Herald* reported that Holmes "used to sit and read while the comics were on, and then put away his book when the girls began to peel." "Thank God, I'm a man of low tastes," he was quoted as saying.[43]

Although it was the largest theater on 9th Street and the only one dedicated to burlesque, the Gayety was surrounded by other theaters, restaurants and arcades. Two doors down on the right was the Leader Theater, built in 1910 with decorative excesses to rival the Gayety's. It was primarily a venue for motion pictures, as was Harry Crandall's Joy Theater and Tom Moore's Garden Theater, both in the 400 block of 9th Street immediately to the south. Crandall's Theater, at the southeast corner of 9th and E, lasted only into the 1920s, while Moore's Garden Theater, rechristened the Central Theater when Crandall took it over, continued much longer.

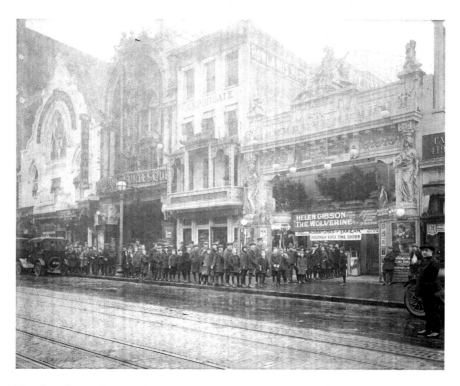

Newsboys line up for a special matinee at the Leader Theater on 9th Street, circa 1921. The Gayety Theatre is on the left. *Library of Congress.*

As the neighborhood began to decline in the 1940s, the pretense of respectability was abandoned altogether. Peep shows and pornography became the coin of the realm. The 1,500-seat Gayety, designed for full-scale theatrical productions, found that it was losing money in this new world and held its last burlesque show in February 1950. However, the timing turned out to be fortuitous, and the theater got an unexpected reprieve.

Washington at that moment was woefully short on stage facilities. The National Theater, previously the only legitimate theater in the city, had converted to movies in 1948 in response to a boycott by the actors' guild over its policy banning admittance of African Americans. In February 1950, an agent for a Broadway show called *The Barretts of Wimpole Street* learned that the Gayety had closed and decided to see if he could book it for his production. Thus in March 1950, after a modest bit of renovation, the Gayety proudly reopened as a legitimate theater with admittance to all races. *The Barretts of Wimpole Street* had a short but successful run, followed by several other productions. It seemed for a time as if the grand old building had successfully entered a second life.

Soon the building was purchased by the Shubert theater chain, which undertook more extensive renovations, including replacing the gaudy façade with a more standard theater entrance. The new playhouse reopened as the Sam S. Shubert Theater. Stars such as John Gielgud, Tallulah Bankhead, Celeste Holm and Maurice Chevalier played there, and President Truman was a frequent attendee. Still, this newfound success was fleeting. By the mid-1950s, few theatrical productions were coming to Washington, and the Shubert was dark more often than not.

Then, at about 1:00 a.m. on January 29, 1959, not long after a showing of Edward Chodorov's *Listen to the Mocking Bird* had ended, fire broke out backstage at the Shubert and quickly grew out of control, consuming scenery, backdrops and, soon, the back of the theater itself, bursting through the roof. Firemen battled the blaze for nearly an hour before it was finally extinguished. While the back of the theater was burned out, the old fireproof asbestos stage curtain had done its job and kept the flames from spreading into the auditorium. Nevertheless, there was extensive smoke and water damage there as well. It was a devastating blow for the old theater, and the owners decided to sell the property rather than undertake repairs.

When word came out in June that the theater would likely be razed and replaced with a parking lot, there were a number of calls to save it. Possibly it could become the new home for the Washington Opera Society, some hoped. A citizens group was formed to buy the theater for use as a civic cultural center, at least until the planned National Cultural Center (which

would become the Kennedy Center) could be completed. An anonymous benefactor even offered to pay the $150,000 asking price and turn the theater over to the city for that purpose. Unfortunately, by that time the property had already been sold to an agent for Lansburgh's Department Store, which was intent on using the site for a new parking lot. Nothing could be done to stop it, and the theater was torn down in November 1959.

Soon, little was left of the old entertainment district. Leroy F. Aarons, writing in the *Post*, proclaimed in 1964 that "Ninth Street, that once-glorious Dream Street, that Coney Island, Bowery and Times Square rolled into one, has nothing left to remember itself by."[44] His occasion for writing was the announcement that much-loved impresario Jimmy Lake (1880–1967), the unofficial "mayor of 9th Street" who had taken over the Gayety Theater in 1914 and had presided over its glory days, was finally leaving the area. After being forced out of the Gayety, Lake had previously moved his business a block south to the old Central Theater building, which he nostalgically rechristened the Gayety. But he soon came to realize that the burlesque business was dying, and thus he was leaving the area for good in 1964. The "new" Gayety then became a strip joint before it was shut down for lack of business and demolished in 1973.

In 1976, the Gayety name was moved yet another time, to the former Roosevelt movie theater at 508 9th Street, NW, which had been built in 1933. This five-hundred-seat theater, across the street from the site of the original Gayety Theater, continued with a mix of live girls and X-rated films into the 1980s. In 1987, this building and the others alongside it were torn down for a large office building.

Meanwhile, the parking lot on the other side of the street remained for more than four decades. Finally in 2007, Boston Properties, Inc., built an office building, designed by the D.C. firm of Hartman-Cox Architects, on the site. Initial plans were for the Washington Stage Guild to occupy performing arts space on the 8th Street side of the building, where the original Gayety Theater's stage used to be, but funding for that project didn't materialize. Perhaps another group will one day perform in that space.

WOODWARD & LOTHROP: THE SENTIMENTAL FAVORITE

Entertainment takes many forms, and shopping must certainly be one of the most popular. For many longtime Washington residents, the Woodward & Lothrop department store (Woodies, as everybody knew it), filling an entire

nine-story, block-long building at 11th and F Streets, NW, was a source of many fondly recalled pleasures.

Walter Woodward (1848–1917) and Alvin Lothrop (1847–1912) came from New England; Walter was born in Maine to a family of shipwrights, and Alvin came from a Massachusetts farm. They met and became fast friends while working as clerks in a Boston dry goods store beginning in 1870. By 1873, they had started their own dry goods business in Chelsea, Massachusetts, but there was a limit to how much they could expand there. In 1879, they decided that they needed to find a larger market. Woodward traveled to the Midwest—Kansas, Nebraska and Missouri—as well as Baltimore and Washington to size up prospects. In a famous telegram back to this partner, he declared, "Alvin, Washington, D.C., is the place for us."

Woodward seems to have been the hard-charging entrepreneur of the pair, whereas Lothrop was the personable, detail-oriented manager. They opened their first Washington store, called the Boston Dry Goods House, at 705 Market Space, opposite the Center Market, in 1880. The following year, they moved a couple of blocks west to 921 Pennsylvania Avenue, where they filled a larger, five-story shop equipped with a steam-powered elevator. The store had a large sign proclaiming "One Price," meaning that everything in the store was marked with a fixed price, a break from the traditional haggling over prices that was standard in dry goods shops. Woodward & Lothrop, Inc., began to take business away from older, less progressive stores.

The pair of young commercial Turks had their eccentricities, particularly Woodward, a consummate type-A hard-charger with a hair-trigger temper and known for his brusqueness. For example, he insisted on conducting grueling interviews of his agents whenever they returned from buying trips, firing pointed questions at his victims and demanding simple yes or no responses. He also developed the habit of angrily flinging pens across his office if they didn't work properly. As many as six or seven might be strewn about after he had worked his way through the morning's mail, and his secretary would have to wait for a quiet moment, after Woodward had simmered down, to discreetly gather the pens up and replace their nibs.[45]

An important milestone came in 1887 when the store was moved from Pennsylvania Avenue to the corner of 11th and F Streets, NW, part of an emerging trend of commercial establishments abandoning flood-prone Pennsylvania Avenue for the higher ground of F Street. Calderon Carlisle, a prominent attorney and real estate investor, offered to construct a new building for the store at a cost of $100,000. This five-story Carlisle Building became Woodies' headquarters for the next forty years. The building was

A view of the Woodies buildings in the early 1920s. The Carlisle Building is the shorter building at the corner. *Library of Congress.*

designed by James G. Hill (1841–1913), Washington's leading architect. Hill had designed the original Bureau of Engraving and Printing building and was also at work on the Atlantic Building (930 F Street, NW) a block away when he undertook the Woodies project. His Carlisle building was in the emerging Chicago commercial style, with large, arcaded, Romanesque Revival windows; tall showroom floors; and restrained Neoclassical trim. The show windows on the bottom four floors were of "highly polished French plate glass," and inside were woodwork and furnishings of cherry, poplar and mahogany, all equally highly polished. Interior ceilings were painted in "graded shades of light blue and ecru," while the walls were a light terra-cotta color with a hand-decorated frieze.[46]

The building was on the leading edge of department store design and was meant to serve as a prominent entertainment destination, impressing passersby and drawing them in. Once inside, the finest customer amenities were provided, including an elegant reception room on the mezzanine level, enclosed by an ornamental mahogany balustrade, where ladies could wait for their shopping companions to arrive before embarking on a romp

through the aisles. Evidence of the store's technological prowess could be found in the Martin & Hill Electric Cable Cash Railway, a Rube Goldberg contraption that included a small track running in all directions throughout the building's four shopping floors. It transported cash from station to station in small "German silver box cars" that raced about at fourteen feet per second. Mayhem ensued at least once a week when somebody's excitable pet dog, driven crazy by the zippy little boxes, would break loose and go tearing after them, barking madly.

As sales continued to grow, Woodward & Lothrop steadily expanded out into the rest of the block, gradually buying and taking over neighboring commercial buildings that, one by one, were attached to the store complex. In the 1890s, the buildings along F Street were added, all but the Rich's shoe store at the opposite end. Mid-block commercial space was also snapped up. Then a big step came in 1899 when the company bought the large property spanning the north end of the block, which fronted on G Street and had been home to the St. Vincent's Orphanage. After a new home for the asylum was completed north of Eckington in 1901, Woodward & Lothrop immediately began work on a large, new, state-of-the-art addition, completed in 1902.

The 1902 building on G Street remains a striking Gilded Age gem. Designed by Chicago-based architect Henry Ives Cobb (1859–1931), the eight-story building features richly ornamented decoration on its first two floors, with their cast-iron piers proudly made in Jersey City, New Jersey.

The south (F Street) end of the Woodies block appears to contain a single, large building that is similar to the 1902 building but more modern in style. This structure was designed by Washington architect Frederick B. Pyle (1867–1934) in the spare, Neoclassical style that would become his trademark in the 1920s. The design uses South Dover marble on the façade of the lower two floors instead of cast iron, plain brick for the central five stories and ornamented terra cotta at the top. This building was erected in several complex phases. The first part of the building to go up was a slim, one-bay-wide segment on F Street in 1912. The following year, the F Street façade was expanded by replacing several older structures and creating a large, five-bay-wide building in the middle of the F Street side of the block. In 1925, the building was further filled out in the mid-block area behind it, and then finally in 1926 the original Carlisle Building on the corner of 11th and F was replaced, completing the structure as it stands to this day. In-house architect Linden Kent Ashford (1893–1953) designed the 1920s expansions, which matched the original Frederick Pyle design.

Downtown's Booming Businesses

Construction of the 1912 addition to the Woodies Building. *Library of Congress.*

As its building steadily expanded, so did Woodies' workforce, departments and services. Woodies' staff grew from 35 in 1880 to 300 when the Carlisle Building opened in 1887. In 1917, there were 1,700 employees, and in 1954 Woodies employed an average of 4,500 during regular seasons and 6,000 during busy holiday seasons.

The store attempted to provide everything a person could possibly want once they left their home. There was a dining room, a beauty parlor, a travel agency, a messenger service and a tourist information desk. For customers or employees who fell ill, a medical clinic, staffed with a full-time physician and nurses, was on hand. In addition, a variety of nonshopping entertainment was always waiting to delight Woodies' patrons. Beginning in 1890, the store showed free art exhibits to a city that had few other opportunities to see fine art. A show in 1900 featured works by Raphael, Titian, Van Dyke and Rembrandt, on loan from the British National Gallery. A motion picture theater was installed in 1913, and beginning in 1915 it screened special educational films produced by the *Washington Post* for children.

Perhaps most memorable for many Woodies customers over the years were the elaborate window displays, particularly the ones done at Christmastime. A large display department was kept at work, constantly inventing dramatic new window exhibits, many of them unrelated to Woodies' merchandise. The year 1930 saw the popular "Washington of the Future" exhibit. A *Post* article in 1961 described the Civil War centennial display then in Woodies' windows and also mentioned an exhibit of live penguins that had been staged in June, with special air conditioning added to give the animals some modicum of comfort. The company's signature Christmas displays were done in friendly rivalry with other downtown department stores, including Kann's, Hecht's and Lansburgh's, and tended to the warm and cuddly. A 1960 roundup of Christmas displays in the *Post* found a teddy bear village at Hecht's, Santa's blacksmith shop at Kann's and Kittenville, USA, at Woodies. The display department might easily spend more than a year planning for these annual exhibits.

Of course, the shopping was always the most important form of entertainment, and since the store's earliest days, free delivery was offered for all purchases. Woodies' delivery trucks were everywhere in the early years of the twentieth century. As remembered by a *Post* reader in 1984, "The

A Woodies delivery truck loading on 11th Street, circa 1912. *Library of Congress.*

[store's] polished horse-drawn delivery vans were a familiar sight on all the residential streets, clop-clopping along. They were a darkish, reddish color (maroon? mulberry?) and the driver, who handled the reins, wore a matching livery, and so did the 'jumper' on the seat beside him" who carried packages to customers' front doors.[47]

In 1946, the company bought out one of its old rivals, the Palais Royal department store, located in the block just to the north of the Woodies building. The Palais Royal became the Woodies North Building, allowing for significant expansion. The firm soon undertook an elaborate reorganization of merchandise, spreading everything out between the two buildings, and in 1951 an underground tunnel was completed connecting them under G Street. In that same year, a 240-car parking garage was constructed just north of the Palais Royal building, marking the furthest extent of Woodies' downtown property (a striking Art Deco warehouse and service building had also been built near Union Station in 1937).

The purchase of the Palais Royal store in 1946 had included conveyance of its leases to three small suburban branches, which Woodies maintained as its own stores. Two were in Arlington (one in the Pentagon concourse) and another was in Bethesda, serving for many years as Woodies Budget Store. But these small stores could not fulfill Woodies' vision of a grand emporium stocked with a multitude of goods. No, the real action beginning in the late 1940s was in developing large suburban stores that would pull people in as shopping destinations, just as the downtown store had done for so many years. As chronicled by Richard Longstreth, the rival Hecht Company was out in front on this trend, opening a large store in the boondocks of Silver Spring in 1947.[48] Woodies responded in 1950 by opening its luxurious Chevy Chase store, designed in a dowdy, semineocolonial style but with an interior by the preeminently modernist Raymond Loewy firm. Woodies went on to add more than a dozen additional suburban branch stores in the 1950s and 1960s, most of them located in the mammoth shopping malls that were then attracting so much business.

The company was always known as Woodward & Lothrop (that is, after a third partner, Charles E. Cochrane, was bought out in its first year). While the store itself was initially called the Boston Dry Goods House, that moniker was dropped at some point before World War I. The "Woodies" nickname came much later and apparently was an irritant to some. The *Washington Post* reader who in 1984 remembered the old delivery trucks also testified that it was not until the 1960s "that I first heard [the store] referred to as 'Woodies,' and then by teen-agers who were too lazy to utter five syllables. And it was

a long time after that before the store itself succumbed and began using 'Woodies' in its ads. As for me, I still say Woodward & Lothrop's."[49]

So what went wrong? How did the company go from such dominance of D.C. retailing to bankruptcy in 1994? Woodies may have been innovative in 1880, but by 1980 it was too set in its ways and falling behind. Deep-pocketed outsiders, like Bloomingdale's, Nordstrom and Neiman-Marcus, began moving into the Washington area and aggressively catering to upscale shoppers. Other national retailers also successfully focused on specific types of products rather than offering a bit of everything, as had been Woodies' forté. The company—not unlike other old-time department stores—seemed unable to recast itself for the new age of retailing. It was only a matter of time before the venerable chain folded.

The downtown building underwent a very restrained face-lift, overseen by noted postmodernist architect Michael Graves, in 1986. After Woodies declared bankruptcy in 1994, Federated Department Stores bought the chain's assets, converting some of the stores to the Hecht's nameplate but abandoning others, including the original downtown location. In 1996, the building was bought at auction by the Washington Opera for $18 million, using money donated by Betty Brown Casey. The opera company hoped to convert the building for use as a theater, but the cost of doing so proved unaffordable, and the building was sold again, in 1999, to developer Douglas Jemal for $28.2 million. Jemal renovated the structure in 2002 to provide office space on the upper floors and retail at ground level.

THE GREYHOUND BUS TERMINAL:
CROSSROADS OF THE CITY

Travel just two blocks north of the Woodies building on 11th Street, and you will reach a wonderfully open urban space—a broad stretch of New York Avenue with triangles of parkland framed by busy north–south streets on each side. The spot could make for a handy transportation hub, and it was just that for almost half a century, hosting the Greyhound Bus Lines Super Terminal on the south side. Thanks to the valiant efforts of the D.C. Preservation League, the Art Deco Society of Washington and the Committee of 100 on the Federal City, the former terminal, completed in 1940, survives today nearly intact as the entrance pavilion to a modern office building at 1100 New York Avenue.

Downtown's Booming Businesses

The terminal is a classic Art Deco (or Moderne) landmark with a streamlined 1930s look that epitomizes the promise of the industrial age as the hope for the future and the savior of civilization. The stepped central tower, a typical "ziggurat" design, exudes freshness and optimism with its clean, triumphal lines. The smoothed corners and streamlined look of course also suggest the speed with which Greyhound's Super Coaches were to whisk you to your destination. The building's architect, Louisville-based William S. Arrasmith (1898–1965), designed more than fifty streamlined bus stations for Greyhound in the 1930s and 1940s, and this Super Terminal may be his finest. The building's exterior is faced in Indiana limestone and neatly rimmed along its upper edges with glazed black terra-cotta coping. Aluminum trim and glass block accentuate the entrance. Inside, the floor of the large central waiting room was originally a jazzy checkerboard terrazzo, the walls partially finished in walnut and trimmed in burnished copper. Large photo murals of scenic places throughout the United States were on the upper portions of the walls. Formica—one of those wonderful new synthetic materials—was used in shades of dark red, brown and gray for wainscoting, columns and countertops.

Greyhound got its start on the back roads of Minnesota, where Carl Eric Wickman began a jitney service for iron miners in 1914. The company grew rapidly through a series of mergers and acquisitions, becoming one of the largest in the United States by 1929. The company's expansion mirrored

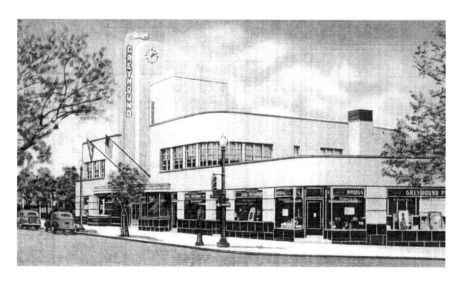

Postcard view of the Greyhound Bus Terminal shortly after completion. *Author's collection.*

the growth of the industry, which was so rapid that cities like Washington struggled to deal with the congestion it created. The city's newspapers from the 1920s and '30s are filled with articles about new bus services and decisions by the Public Utilities Commission to try to limit their takeover of city streets. While stations were situated at a variety of downtown spots, New York Avenue was a particularly attractive location because it connected directly with highways to the east. Before the Super Terminal, Greyhound had built a restrained Art Deco station near the northwest corner of 14th Street and New York Avenue in 1933. Called an "imposing addition to the architectural beauty of the city," by the *Washington Post*,[50] that terminal could accommodate just twelve buses, with two loading and unloading lanes. It lasted only five years before the company decided to build the much larger Super Terminal two blocks to the east.

The new station opened to great acclaim in March 1940. On opening day, twenty-five thousand gawkers filed in, admiring the stylish decor and all of the leather and aluminum. A swing band played, and some people danced where they could find room. Each guest was given a "souvenir," the newspapers tell us, although what it was we do not know. The $1 million, fully air-conditioned new building seemed to impress everyone to no end.[51]

The timing of the opening was propitious, coming just before hordes of servicemen and other government workers began inundating the city to fuel the war effort. The terminal was quickly overrun with business. In May 1943, Wilson Scott wrote in the *Washington Times-Herald* of his impressions of the wartime bus station. He noted that "[o]n Sunday nights in addition to the regular buses, almost 2,000 service men are transported back to camp between the hours of 6 p.m. and 12 midnight...I have often seen a long line of soldiers, sailors and sweethearts on Sunday night wrapped around almost three full sides of the block on which the terminal stands and waiting seats." Ever present were military police and shore patrolmen along with their Black Marias and patrol wagons, ready to nab any troublemakers or servicemen who had gone AWOL. On a more poignant note, Scott found a civilian cop trying to comfort a bedraggled young boy who had run away from home two days before: "Dressed in a gray sweater and corduroy knickers extending practically to his ankles and looking out with timid, forlorn eyes on a cold, cold world, the little lad was too frightened to talk." After trying his best to communicate with the child, the cop finally called a police wagon to take him away, which probably didn't help much to settle the young boy's anxiety.[52]

The *Washington Star* reported in July 1945 about a war-bereaved father from Newark, New Jersey, whose son had gone missing in the Pacific. After

drinking heavily one night, the man walked into the Greyhound terminal and shot an apparently total stranger and then turned the gun on himself. The stranger, hit in the stomach, survived; the distraught father died later that night at Emergency Hospital.[53]

The station stayed busy for several decades after the war. In 1973, Henry Allen wrote a wonderful profile of the aged Greyhound terminal for the *Washington Post*, finding not stylish elegance but "that bus station smell…the stale, sweet, sooty urban smell of cigar smoke, sold sweat and carbon monoxide; the tart, grimy smell of winos, and the starchy air of the cafeteria, like the mess hall of a troop ship." The station had changed. Instead of sumptuous benches upholstered in leather, Allen noted the "plastic seats with bolted-on TV sets that nobody watches." About the architecture, Allen reported with a jaundiced eye that "the downtown Greyhound station epitomizes the march-of-progress school of architecture that scattered its sculptured monuments around the country before World War II"—a futile and naive gesture, he seemed to be thinking. And it was hard not to be jaded at that point, surrounded by the assortment of "pimps, pickpockets. winos, junkies, whores, transvestites, Murphy men, pushers, all-round hustlers and restroom commandos" that populated the terminal on a semipermanent basis. There were still plenty of servicemen moving through the station, but now they were mostly prey for the hustlers. "These guys go down to the pet store on H Street, buy three-quarters of an ounce of catnip for 51 cents. It makes a good-looking ounce of marijuana. You sell it to these GIs," Allen learned. Finally, Allen talked to a young woman sitting in the station's restaurant: "'You want to know why I hang in here?' she asks…'I'll tell you,' she says with sudden ennui, 'I just don't know myself.'"[54]

The old terminal's Art Deco ebullience, it seems, had become almost an embarrassment on the mean streets of downtown in the 1970s. Greyhound execs must have thought so when they decided in 1976 to box the whole thing up. Architect Gordon Holmquist came up with a renovation based on installing concrete asbestos panels and a squat-looking metal mansard roof around the entire building. The resulting look was certainly restrained, but in an awkward and ungainly manner. In retrospect, it's hard to fathom what the Greyhound people were thinking.

By the mid-1980s, the Greyhound terminal had reached the end of the road, so to speak, at least as a bus station. Real estate in the old downtown was beginning to pick up, and the property had become quite valuable. Greyhound sold its station for $21 million in 1985 and, after acquiring rival

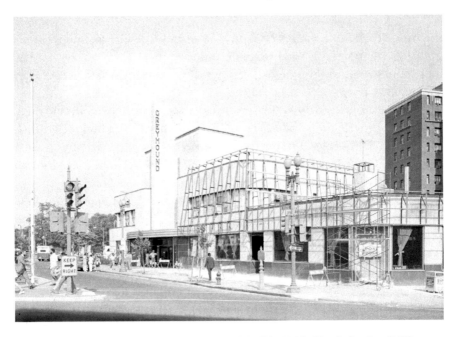

The Greyhound terminal as it was being "remodeled" in 1976. *Historic American Buildings Survey, Library of Congress.*

Trailways in 1987, consolidated bus operations at Trailways' new terminal behind Union Station.

Led by Richard Longstreth of the Committee of 100 and Richard Striner of the Art Deco Society of Washington, a coalition of preservationists rallied in the early 1980s to get the old terminal designated as a historic landmark. Their efforts were complicated by the fact that the original façade was covered over and its condition unknown. The developers at first thought to just incorporate elements of the façade in their new monster office building, but preservationists wanted the entire building saved, and they mounted a sophisticated campaign to make it happen. Finally, a breakthrough was reached in 1988 when the developers and the future owners of the office building agreed to a 10 percent decrease in total office space that would allow the entire terminal to be saved as a gateway to the new building. The handsomely restored bus station cum office building opened in 1991. It includes a striking permanent exhibit on the history of the bus terminal, complete with life-size plaster casts of historic buses standing precisely where their bays would have been at the back of the original terminal.

Part IV

GEORGETOWN

The land area designated as the District of Columbia originally contained three separate towns: Alexandria at the District's southern tip, the new town of Washington City in the center and Georgetown, a tobacco port on the Potomac River to the northwest that had been founded in 1751. Georgetown remained a separate town within the District of Columbia until late in the nineteenth century. Because Washington was such an uncertain and unfinished enterprise in the early 1800s, many visitors and residents alike chose to stay in Georgetown. Most of the important work of establishing and laying out the new city of Washington was actually done in Georgetown, and prominent early residents, such as Francis Scott Key, preferred to live there. The Georgetown waterfront was destined to become highly industrialized—and then quite run down—before being revived by gentrification in the late twentieth century.

WHERE WAS SUTER'S TAVERN?

There's a charming little National Park Service site at 3051 M Street in Georgetown, known as the Old Stone House, that may be the oldest surviving structure in the District of Columbia, dating to 1765, when a certain Christopher Layman built it as a carpenter's shop and living quarters. Solidly built in the "Pennsylvanian" vernacular style, the little building looks hopelessly out of place on bustling modern-day M Street. Why, then, has it been preserved when all else seemingly was lost, and why has it been taken

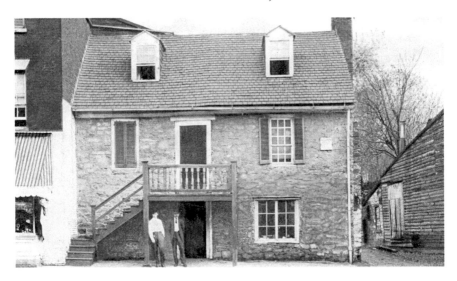

Postcard view of the Old Stone House, circa 1910, labeled "Gen. Geo. Washington's Headquarters while Surveying the City of Washington, D.C., in 1791." *Author's collection.*

over by the park service? What momentous historical personage or event is connected with it? The answer: nothing, really.

The house was certainly once thought to be very historically significant. Old guidebooks and postcards call it "Gen. Geo. Washington's Headquarters while Surveying the City of Washington, D.C. in 1791." So then, if that's not true, how did the confusion arise?

George Washington did indeed stop in Georgetown for a few days in 1791 to make arrangements for the new federal city that would be named after him. He met with landowners, surveyors and his newly designated city planner, Pierre L'Enfant (1754–1825). Subsequently, L'Enfant also had his "office" at this same meeting place in Georgetown while he was laying out his brilliant grid of streets crisscrossed by grand diagonal avenues. The three commissioners for the new city, charged with administering early road and building construction efforts, likewise worked from the same Georgetown location. That location was Suter's Tavern.

In those days, travelers often sought lodging in tavern houses, and Georgetown's most famous tavern, where everybody went, was Suter's, opened by John Suter in 1783 and known officially as the Fountain Inn. It seems that all important business was conducted there, from the planning work for Washington City to Georgetown's own early municipal meetings. George Washington was hardly unique in stopping there. Thomas Jefferson

once stated that "no man on the Atlantic coast can bring out a better bottle of Madeira or Sherry than old Suter." So then, where was Suter's Tavern? Was the Old Stone House actually Suter's Tavern?

Now, nobody ever recorded street addresses in those days—there simply was no need—so it's not clear exactly where Suter's was located. Compounding the problem is that fact that Suter didn't actually own the property that he used for his tavern, and thus there isn't any deed of sale to specify the tavern's precise location. As the nineteenth century wore on, people who had known Suter's firsthand passed away, and knowledge of its location was quickly lost.

In December 1902, the *Washington Times* reported about the Old Stone House that there was "a tradition that schoolchildren playing in the attic of this little building many years ago found some drawings and plans which seemed to have some relation to the early plans of the city." Maybe that thin shred was what led someone—supposedly with the support of contributions from schoolchildren—to put the first of a series of markers on the house claiming that it was Washington's "headquarters." Such a marker seems to have been there as early as the 1870s. However, the *Times* author noted that "on the other hand we are informed that there is no authentic history which points to any occupancy of this house by President Washington on any occasion," so the doubts about the story seem to go back nearly as far as the story itself.[55]

Nevertheless, Georgetowners liked the little stone house and the idea that it was "Washington's Headquarters," and it seems that there wasn't much concern about getting to the truth of the matter. Postcards and tour books were produced celebrating the little place, and intermittent efforts were made to preserve it. A bill was introduced in Congress in 1929 to make "Washington's Engineering Headquarters" a national monument with an engineering theme. But local historians came out against the idea. Allen C. Clark, president of the Columbia Historical Society, stated that "the face of the Old Stone House has been a haven of historical markers. These have been false in their message." The bill was not enacted, and that was that—at least until Ms. Bessie Wilmarth Gahn joined the fray in 1940.

Gahn seems to have made the most ambitious attempt on record to claim that the Old Stone House was Suter's Tavern. She wrote a whole book on George Washington's Headquarters in Georgetown in which she provided very detailed research showing that Washington had made Suter's Tavern his headquarters in Georgetown (true enough) and that, because John Suter's son had a connection to the Old Stone House, it must have been

A fanciful drawing of Suter's Tavern, as it appeared in *Perley's Reminiscences of Sixty Years in the National Metropolis*, published in 1886.

Suter's Tavern (not true at all).[56] Despite gaining a lot of attention at the time, Gahn's analysis left many in doubt.

So where was Suter's Tavern, really? National Park Service historian Cornelius W. Heine wrote what seemed to be a definitive study of the Old Stone House in 1955, after it had been acquired by the government.[57] In it he presented with great fanfare his research into what he called "Washington's Most Unusual Mystery"—the location of Suter's Tavern—a "seemingly insoluble mystery" that "has intrigued and baffled local historians to this very time." He went on to provide fairly convincing evidence that the tavern had been located down on K Street, on its northwest corner with 31st Street. Central to his analysis was his discovery at the Library of Congress of "a certain unusual photograph...among an old miscellaneous collection."

Heine found that "[w]hen the photograph was turned over, there on the back, in old but bold penmanship were the words 'Suter's Tavern.'" The mystery was solved!

Or was it? Many people thought that the case was closed at that point. The *Washington Post* reported in September 1955 that the site of Suter's Tavern had finally been pinpointed, quoting National Park Service director Conrad L. Wirth as saying that the facts gathered by Heine "prove conclusively" that the site of the tavern had been found.[58] The Georgetown Citizens Association approved erection of a historical marker, and one was soon in place at the site. By that time, the spot was just an empty corner of a block owned by the D.C. government, on which the Georgetown incinerator was also located. Not everyone was convinced that the mystery had really been solved, however. As Bessie Gahn had observed, the site on K Street was not likely even habitable in 1791, when marshes on the edge of the Potomac probably still extended over the area. Others had said that Suter's Tavern was elsewhere, notably Christian Hines (1781–1874), a prominent early Georgetown resident, who in his *Early Recollections of Washington City* had located Suter's on High Street (now Wisconsin Avenue) just north of where it is now crossed by the Chesapeake and Ohio Canal.[59]

In 1986, before the D.C. government sold the old incinerator property for redevelopment, it commissioned the firm of Garrow and Associates, Inc., to do an archaeological investigation of the 31st and K Street site to try to determine through direct physical evidence whether the claim that it was the location of Suter's Tavern was plausible. It turned out not to be. The archaeologists determined from remains found on the site that it was not inhabited before about 1810 at the earliest and that there were several layers of earthen fill deposited there, on which all later structures had been built. So this theory, along with the Old Stone House theory, was shot down, and we may never know for sure where the incredibly important Suter's tavern was actually located.

But let's go back to the Old Stone House, because it was this charming little building that everyone wanted to save. Christopher Layman died shortly after the house was built, and his widow sold it to one Cassandra Chew. One of Mrs. Chew's daughters, Mary Smith, was living in the Old Stone House at the time that George Washington and Pierre L'Enfant were staying at Suter's, somewhere nearby. Beginning in 1800, John Suter Jr., son of the proprietor of Suter's Tavern, rented the Old Stone House and set up his clockmaker's shop in the basement commercial space there. In fact, one of his tall-case clocks is on display now at the restored building. Subsequent

occupants used the house for a tailor's shop, a house painter's shop and an antiques store.

By 1950, it didn't matter anymore whether Washington or L'Enfant or anybody else had ever done anything of importance there—it was a wonderful old house, and it was threatened by the commercial expansion of Georgetown. Grimy, commercial Georgetown was on the cusp of a new trend toward gentrification, and while many historic buildings survived, many others were threatened. Plans had been announced to tear down the Old Stone House and replace it with a modern commercial building. The Georgetown Citizens Association, which envisioned a "Williamsburg" along M Street of restored or re-created historic buildings, pushed to have the federal government acquire the Old Stone House for the park service, which restored it in the late 1950s. Meanwhile, Georgetown became fashionable once again, and M Street and Wisconsin Avenue turned into prime sites for expensive shops and galleries. The K Street area down by the river would take a lot longer to come back, and well, the real Suter's Tavern was lost anyway, wherever it had been. Oh, and that marker that had been set in the ground on the corner of 31st and K Streets? After the property was redeveloped, the marker was lost, too. So just use your imagination.

KEY MANSION: THE MISPLACED HOUSE

Of course, Suter's Tavern is not the only historic Georgetown building that's been lost. If you believe the *Washington Post*, another Georgetown landmark was lost in a more literal way. In a breezy May 1981 article entitled "The Case of the Lost Landmark," the *Post*'s Tom Zito relished what he took to be a highly amusing case of bureaucratic bungling. "Misplacing a house key is one thing," Zito intoned. "Misplacing a Key house is quite another." In interviews with officials from the National Park Service, Zito had found that the home of Francis Scott Key (1779–1843), writer of "The Star-Spangled Banner," which used to stand on M Street close to the Key Bridge, was torn down in 1947 and its parts saved for possible reconstruction later. However, it seems that the park service subsequently had misplaced these parts and in 1981 could no longer find them. Oops!

The full story of what happened to the house and how it was almost saved several times is much more complicated. It's a tale of wishful intentions tempered by bad luck and unfortunate timing. If a few circumstances had been switched around, the house might still be with us today.

Georgetown

Francis Scott Key. *Library of Congress.*

The rather simple Federal-style house was originally built by a merchant named Thomas Clark in 1795, long before any bridges or the Chesapeake & Ohio Canal disrupted the landscape around it. In those days, terraced gardens sloped down gracefully behind the house to the peaceful Potomac River. Francis Scott Key leased the house in late 1805 and was residing there in 1814 when he went on his mission of mercy to Baltimore to secure the release of Dr. William Beanes from the British. While detained on a British ship in Baltimore Harbor during the siege of Fort McHenry, Key penned what would become our national anthem.

In about 1830, Key and his family moved out of the Georgetown house for a place nearer Judiciary Square in Washington City, where he was district attorney. It is said that the cutting of the C&O Canal directly through his backyard, and the resulting noisy boat traffic, had greatly reduced the desirability of the place as a residence.

The formerly quiet residential neighborhood seems to have gone downhill from that point forward. By the end of the nineteenth century, the lower parts of Georgetown were a messy industrial area. Georgetown's days as a thriving tobacco port were long gone. The harbor had silted up, and seagoing vessels could no longer dock there. What remained were grimy factories and mills. The Key mansion by the 1890s was being used as a

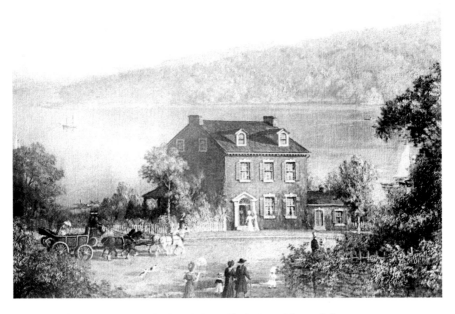

Drawing of the Key mansion in Francis Scott Key's time. *Library of Congress.*

commercial shop rather than a residence. Plans in 1896 to greatly expand the building, making it into a thirty-two-room hotel, never materialized.

Then, one day about 1899, Francis Scott Key Smith (1874–1951), great-grandson of Key, was walking along M Street in Georgetown and noticed the dilapidated appearance of the mansion:

> *I was very much mortified by its appearance and the sad state of decay. One parlor window had been cut down to the level of the street, and, thus converted into a door, served as entrance to a cobbler's shop conducted in the once handsome parlor. Mr. Key's office, to the right of the residence as you enter, was occupied by a cheap Italian fruit and peanut stand. The house, then as now, was literally plastered over with signs advertising cheap wares of various descriptions.*[60]

When plans were announced in 1906 to tear down the old house and replace it with commercial shops, Smith was spurred into action. He contacted other prominent individuals, including Admiral George Dewey (1837–1917), several Supreme Court justices and others to form a group to save the mansion as a memorial to the author of the national anthem.

The Key mansion as it was decorated for Flag Day in 1908. *Library of Congress.*

The Francis Scott Key Memorial Association was enthusiastically chartered the following year, but few funds were raised to buy the house. At Admiral Dewey's urging, a Washington attorney, Hugh T. Taggart, purchased the house and leased it to the group, which set about festooning it with flags and a large portrait of Key. The "museum" was opened in February 1908; visitors were greeted inside by the group's business manager, who would entertain them by pitching the organization's goal of purchasing the house and soliciting contributions.

The group set a goal of raising $15,000 to purchase the house and operate it as a permanent museum. Others had made a similar move to save the Betsy Ross House in Philadelphia in 1898; why not do the same thing with the Francis Scott Key House?

Unfortunately, this well-meaning effort was doomed from the start. The Key mansion was located at the far end of Georgetown's then tawdry commercial strip, and tourists didn't particularly want to go there. Plus, the drab-looking building was empty—no historic furnishings and nothing really to see. Elaborate membership certificates were produced,

to be bestowed on those who would contribute a dime or a quarter. It didn't work.

When attorney Taggart died in 1912, his heirs promptly kicked the association out and set about drastically modifying the structure to turn it into a plain commercial storefront. The entire gabled top floor was removed and replaced with a flat roof. The distinctive split chimney on the side of the house was also removed, as was Key's office, which had been a historic addition on the west side. Finally, the entire façade of the building was removed and replaced with new brick and large plate-glass commercial windows. At this point, you couldn't tell it was the Key House anymore; it looked like any other one-story shop. It was so unrecognizable that many people thought that the house had been torn down "to make way for the new Key Bridge," a misconception that occasionally still appears in written histories of Georgetown.

The house, in fact, was still there after the bridge was built in 1923, but its days were numbered. The government acquired the properties in the block along M Street north of the bridge in 1931 as part of a new Palisades Park. Then people started talking about saving the house again—or rather reconstructing it. By 1935, the park service had developed plans to do just that, aiming to use what few original elements remained in what would be a largely new building. When approval came in 1941 to build a ramp to the new Whitehurst Freeway through the site of the house, it was time for a final decision to be made.

The prevailing opinion at that time among many leading Washingtonians was that the Key mansion be preserved in some fashion. The Columbia Historical Society published a pamphlet in 1947 urging it be preserved, restored and turned over to the group to use as its headquarters.[61] This was probably asking too much, but Congress did pass a bill to fund construction of a replica of the house on the other side of Key Bridge, using its remaining original elements, after the new Whitehurst Freeway had been completed. Following that plan, contractors dismantled the house, numbered the original bricks and foundation stones and placed them on the site just south of the bridge where the replica building was supposed to be constructed.

But a new wrinkle emerged at this point. The Bureau of the Budget objected to the funding measure on the grounds that the replica house would cost too much to build and maintain—and besides, it would just be a replica, not the real thing. President Harry S Truman took this advice and pocket-vetoed the bill in 1948 that would have paid for construction of the replica house.

Thus, what the park service really lost was that pile of numbered bricks and foundation stones, which suddenly had no purpose after the scheme for the replica house went unfunded. It's true that no one knows exactly how they disappeared over the years, but presumably they would have made useful materials for rehabilitating old houses throughout Georgetown. One theory is that the park service itself used at least some of the material when it restored the Old Stone House in 1957.[62]

So is it the National Park Service's fault that the Key mansion was lost? Perhaps the real opportunity to save the house was lost in 1908, when public apathy conspired with an ill-conceived house museum business plan to doom the Key mansion to oblivion.

Part V

DUPONT CIRCLE AND ADAMS MORGAN

Dupont Circle, now generally considered to be solidly downtown, was once a suburb, just to the northwest of Washington City. The area at the western end of Massachusetts Avenue was wooded and marshy through the Civil War era and only became attractive as a residential neighborhood after streets and utilities were installed in the early 1870s. By the 1880s, its quiet, open spaces became the perfect locale for wealthy Washingtonians to erect their lavish Gilded Age mansions. Local churches soon felt the need to follow their influential members to their new neighborhoods, a prime example being the Presbyterians from Abraham Lincoln's church on New York Avenue downtown who organized the Church of the Covenant.

As a residential neighborhood, Dupont Circle peaked in the years before World War I. By the 1920s, commercial structures began replacing some of the mansions, and wealthy residents began moving farther away. The high ground north of Dupont Circle, now called Kalorama Heights and Adams Morgan, began attracting lots of residential development in the 1910s and 1920s. The pocketbooks of these potential moviegoers attracted theater mogul Harry Crandall to build his grand Knickerbocker Theater in the heart of this neighborhood in 1916.

THE LOST CHURCH OF THE COVENANT

One of the city's greatest losses in historic religious structures was the old National Presbyterian Church, originally called the Church of the Covenant, which used to rise from the southeast corner of Connecticut Avenue and N Street, NW, just south of Dupont Circle. The building, which James M. Goode has called a "dignified masterpiece in gray granite,"[63] was completed in 1889 and torn down in 1966, to be replaced by a nondescript office building.

The church was designed by New York architect J. Cleveland Cady (1837–1919), a devout Presbyterian who is best known for designing part of the American Museum of Natural History in New York City. For this

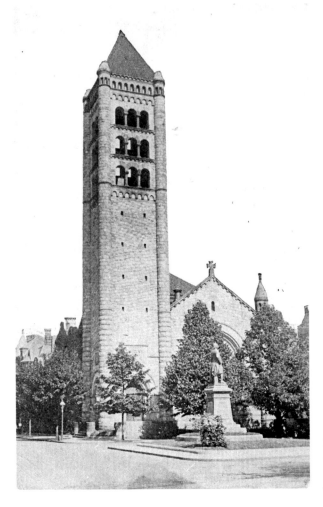

Postcard view of the Church of the Covenant, circa 1910. *Author's collection.*

building, Cady adopted the Romanesque Revival style popular in the late Victorian era, replete with heavy rounded arches and rough-cut stone facing. H.H. Richardson's celebrated Allegheny County Courthouse had just been completed in Pittsburgh in 1886, and it clearly influenced both this building and W.J. Edbrooke's grand Post Office Department building on Pennsylvania Avenue, another great D.C. landmark in this style.

In the early 1880s, members of the New York Avenue Presbyterian Church near the White House had decided that they needed to reach out to the far northwest part of the city (i.e., Dupont Circle) to keep up with the wealthy "top hats" that increasingly were moving out to that wealthy suburb. They founded the Church of the Covenant in 1883 and built a small chapel the following year.

Construction of the main church began in 1887 and was nearly complete when catastrophe struck. The church's 158-foot Ohio sandstone tower suddenly collapsed into a heap of rubble early on the morning of August 22, 1888. Cady's Washington representative, Robert I. Fleming, had been on hand the day before to inspect construction progress and realized that the tower was in jeopardy when a large crack appeared in one wall. Fleming ordered the site watchman, Thomas Neal, to keep people away for their own safety. Neal told the *Washington Critic* that he heard cracking sounds coming from the tower at regular intervals beginning at about ten o'clock that night. A policeman making his rounds at about 4:30 a.m. the next morning noticed the strange noises and was about to go inside to investigate when Neal warned him away just before the whole thing fell to the ground. The *Washington Post* reported:

> *The crash and falling stones was like a peal of thunder, and before it ceased a cloud of white dust rose from the ruins, completely enveloping the building and hiding it from the view of the two startled spectators. Long before the air became clear the whole neighborhood was aroused. Windows were thrown open and scantily-clad figures ran from the houses, under the impression that there had been an earthquake.*[64]

What caused the collapse? Fingers were pointed in all directions. "It was the fault of the contractor; it was the fault of the architect; it was the fault of the trustees, of the material, of the mortar, of everything and of nothing," the *Post* reported with exasperation. An official investigation soon concluded that the basic design was sound but that inferior materials and workmanship were to blame for the accident. The mortar, in particular, was found to be

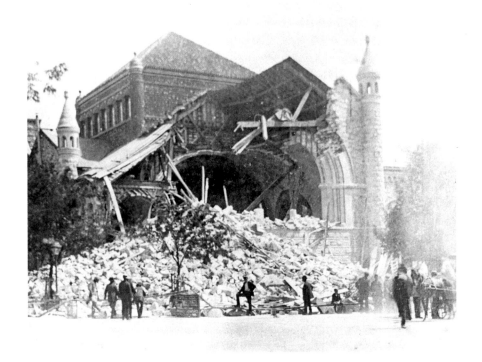

The collapse of the newly built tower of the Church of the Covenant in August 1888.
Archives of the National Presbyterian Church.

"practically worthless." The architect, contractors and church congregation agreed to divide the cost of reconstruction equally, and a new and very solid tower was soon in place.

The finished church was an exquisite homage to its Byzantine as well as Romanesque forbears. The squarish interior spaces were defined by sweeping vaults with elaborate plasterwork ceiling decoration. The central nave was crowned by a massive square "lantern" with clerestory windows allowing light to shine in from the heavens. On three sides, stained-glass windows made by the New York firm of Tiffany and Booth illustrated the life of Christ. Finally, in the center was a grand, gas-powered brass chandelier, fifteen feet wide, that was paid for with monies donated by the children of the church's Sunday school classes. The impressive Byzantine-style chandelier was made in Philadelphia and was inspired by a similar fixture in the Hagia Sophia in Constantinople. It duly contributed to the church's reputation as the "Hagia Sophia of Washington."

The new church prospered and grew, especially after it absorbed the congregation of the historic First Presbyterian Church, which was

located on John Marshall Place near the old D.C. Courthouse. The city government employed eminent domain to seize that property in 1930 to provide space for a municipal complex. The Connecticut Avenue church was then renamed the Covenant–First Presbyterian Church to recognize the merger of the two congregations.

Already by that time, a sense had been developing among at least some of the church's leaders that the building on Connecticut Avenue was not enough. Other faiths had national churches in Washington, and some Presbyterians wanted a national church as well—something with sufficient accommodations to serve as a national center. But the sentiment was not unanimous; after all, as David R. Bains pointed out, an essential tenet of Presbyterianism is the equality of ministers, elders and congregations. The idea of one particular congregation having a special status as the national church went against the grain.[65] Yet the desire for a national church persisted, gaining urgency after the church was officially designated the National Presbyterian Church in an October 1947 ceremony attended by President Harry S Truman.

A proposal was made in 1954 to construct a new church building across N Street on a lot then being used for parking, with an underground tunnel to connect the new building to the old church. However, this plan didn't include adequate parking and was ultimately found to be too costly, so the search for a new location continued. A site at Massachusetts and New Mexico Avenues, NW—the former estate of banker Charles C. Glover Sr.—was purchased in 1959, and a preliminary design was developed by architect Edward Durrell Stone (1902–1978) for a grand, $20 million, modernist church complex there. This time, church officials cringed at the expensive, cathedral-like pretensions of the Stone design, and it was dropped in favor of a more modest plan by Philadelphia ecclesiastical architect Harold E. Wagoner (1905–1986).

In August 1963, church officials announced that they had signed a contract to sell the old church building on Connecticut Avenue for $2.6 million to a developer who planned to raze it and put up a much more profitable ten-story office building in its place. It didn't take long for protests to develop. In October, the chair of the National Capital Planning Commission, Elizabeth Rowe, was reported in the *Post* as expressing grave concerns about tearing down the church, which she called "a landmark of the highest significance, both historically and architecturally." This prompted the *Post*'s architecture critic, Wolf Von Eckardt, to bemoan the fact that no one seemed willing to do something to stop the loss of the landmark building, which represented

for him the only structure of distinction still left on Connecticut Avenue. "No office slab could possibly adorn that multiple intersection as well as that cheerful exclamation mark of a tower, nor give it as much poetry as that well-shaped rough stone heap," he proclaimed.[66]

The fight was on, and it continued for three more years. Robert R. Garvey Jr., head of the National Trust for Historic Preservation, called the planned demolition a "catastrophe," although he recognized that, with no historic preservation laws yet on the books, he had little power to stop it. The property had been rezoned to allow for construction of the planned ten-story office building, so unless someone was able to come forward with substantial funds to take over the property and find a new use for it, the numerous protests that were organized had little chance of preventing the demolition.

With no viable options left, the building came down in July 1966. Workmen first removed the Tiffany stained-glass windows, the historic pews that presidents had sat in and the great chandelier paid for by the Sunday school children. These items were saved for reinstallation in the new church

Workmen remove the great brass chandelier, donated by schoolchildren, from the Church of the Covenant in July 1966. The chandelier was later reinstalled in the new National Presbyterian Church on Nebraska Avenue, NW. *Historic American Buildings Survey, Library of Congress.*

building. The *Post* reported that on one day passersby were sent scurrying by a wall that tumbled down unexpectedly during the demolition. This was a brick wall in an adjoining structure, not the solid granite walls of the church itself. In fact, according to J. Theodore Anderson, the church's iconic tower, which had been so poorly constructed the first time around, proved particularly obstinate when the wreckers attacked it seventy-eight years later.

A bland office box, typical of its era, was erected on the site, although it was only eight stories instead of ten. In 2007, that building was stripped down to its concrete frame and resheathed in contemporary tinted glass. Aesthetically, the improvement seems marginal. We're still short the commanding presence of that marvelous church tower, the victim of what Wolf Von Eckardt darkly called "criminal urbicide," our collective failure to preserve the city's cultural heritage.

Harry Crandall's Knickerbocker Theater

While the Church of the Covenant was faithfully serving the spiritual needs of its congregation, theater mogul Harry M. Crandall (1879–1937) aimed at more mundane wants and desires. Crandall's relatively brief but dramatic career speaks volumes about the impact of the golden age of motion pictures on the city of Washington. Crandall was an early pioneer whose innovations in the movie theater business heralded profound changes in the city's entertainment scene.[67] He gained a great fortune and commercial triumph but also suffered devastating public as well as personal tragedy.

Crandall, a native Washingtonian, was a man with keen instincts and fortuitous timing. Educated only as far as the fourth grade, Crandall had been working as a telephone company test operator in the first years of the twentieth century, when he began to aspire to greater things. One day, while sitting in one of the city's cramped little nickelodeon theaters, Crandall realized that this business was the wave of the future. He began in 1911 with a small theater called the Casino on Capitol Hill but reached his first real success with the opening of Crandall's Joy Theater at 9th and E Streets, NW, in 1914. In those days before modern air-handling equipment, movie theaters were often uncomfortable and even unsanitary. Crandall had an elaborate system of fans installed in his new theater for cooling and circulating air that were a major advance at the time though quite crude by today's standards. He also had the floor of the auditorium canted so that it could be hosed down every night. Patrons, including the female shoppers

Crandall was aiming at, loved the expensive decor and creature comforts at Crandall's, which soon turned handsome profits.

As reported in the *Washington Herald*, Washingtonians were spending $2 million a year by 1915 to see movies, a business that had grown from almost nothing in less than a decade.[68] Crandall knew that the rapid rise in popularity hadn't yet peaked, and he was soon looking to expand his operations to other parts of the city. He set his sights on the wealthy "suburbs" of Mount Pleasant and Columbia Heights, purchasing the 800-seat Savoy Theater at 3030 14th Street, NW, near Columbia Road, in 1916. Later that same year, construction began on the 1,800-seat Knickerbocker Theater at 18th Street and Columbia Road, in what is now the heart of Adams Morgan.

The Knickerbocker, designed by a young architect named Reginald W. Geare (1889–1927), was an impressively elegant cinematic venue, designed with numerous Neoclassical motifs. The first story featured a series of arches in Indiana limestone, creating a blind arcade all the way around the building. The two stories above were of Federal-looking brick, interrupted

The Knickerbocker Theater at its opening in October 1917. *Library of Congress.*

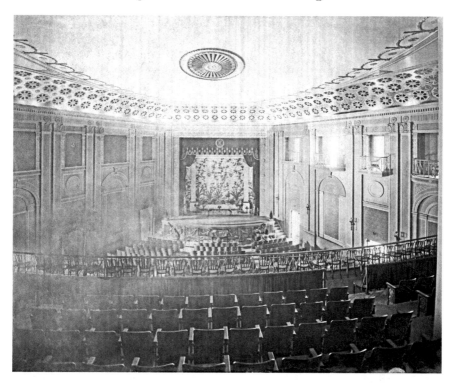

The interior of the Knickerbocker Theater shortly after it opened in October 1917. *Library of Congress.*

by a decorative central limestone section with Ionic pilasters, the whole arrangement giving the appearance that a tremendous mansion built by some scion of the superrich had been given over to entertainment for the masses. Inside, a spacious high-ceilinged foyer repeated the Neoclassical motifs, contributing to the feel of sophistication. Behind the auditorium was a "retiring" room for ladies and a smoking room for men, as well as a Japanese tearoom. The Adamesque furnishings were ivory, gold and old rose; the balcony furnishings were lavender velour; and a "semi-direct, self-diffusing" lighting system was installed to provide atmospheric effects.

The new theater was a big hit, and all went well until January 28, 1922, when the city was struck by a slow-moving storm that dumped up to twenty-nine inches of heavy, wet snow on rooftops over a twenty-four-hour period—the largest snowfall ever recorded for the D.C. area. Despite all of that snow, several hundred people made their way to Crandall's Knickerbocker for its evening shows. Saturday night was comedy night, so everyone was there, including families with young children out for their

weekly entertainment. The feature that night was George M. Cohan's *Get-Rich-Quick Wallingford*, an adaptation of his successful Broadway play.

Shortly after 9:00 p.m., the second show of the evening was just getting started, and the theater was packed. As described in the *Washington Post*, an early gag had just brought hearty laughs from the crowd, when suddenly a gut-wrenching, cracking sound came from above:

> *With a roar, mighty as the crack of doom, the massive roof of the Knickerbocker broke loose from its steel moorings and crashed down upon the heads of those in the balcony. Under the weight of the fallen roof, the balcony gave way. Most of the audience was entombed. It was as sudden as the turning off of an electric light.*[69]

The roof had split in the middle and then fallen through. Some people had seen the split and ducked under chairs or made for the exits, but for most there was no time. The debris of the roof, supporting girders and tons of snow lay like a heavy blanket over several hundred trapped people, many injured or killed. After a few moments of eerie silence, pandemonium ensued as the moans and screams of the injured and dying could be heard and bystanders scurried frantically to help them. Police and firemen who responded quickly found that they could do little to reach many of the victims buried under the heavy debris, and soon the jacks from dozens of nearby automobiles were being used to try to hoist up pieces of the roof and free victims.

As time went by, workers with the necessary tools and equipment to deal with the debris arrived but found that they couldn't get through the mass of thousands of anxious relatives and onlookers who feared that loved ones were trapped inside. By 2:30 a.m., some six hundred soldiers and marines were on hand to keep crowds under control and away from the building and to assist in the intensive rescue operation. A small candy store in the lobby of the theater became the first makeshift hospital room, followed by other neighborhood shops and homes. The nearby First Church of Christ became a temporary morgue. Taxicabs and private automobiles joined dozens of ambulances in struggling through the snow-choked streets to rush victims to area hospitals. When a fleet of four ambulances arrived from Walter Reed Hospital, they were loaded with a dozen victims within five minutes and sent on their way. When rescue operations finally concluded the next day, 94 dead were pulled from the wreckage and 137 were wounded, 4 of whom soon died of their injuries.

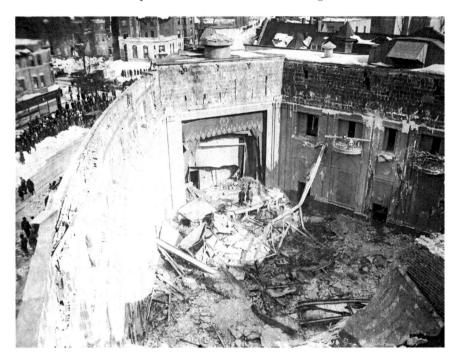

Aerial view of the collapsed Knickerbocker Theater in January 1922. *Library of Congress.*

Inquiries into the cause of the accident began immediately, with accusations flying in all directions. Investigations by various District of Columbia entities, including a grand jury, as well as a separate Senate Committee inquiry, soon began. Many observers doubted that the weight of the snow alone was sufficient to cause the collapse—some structural defect had to be involved. Concerns were raised about building practices throughout the city, and within a few weeks District officials ordered seven other theaters, including the distinguished National Theater on E Street downtown, closed until repairs could be completed. Ultimately, it was determined that the Knickerbocker's roof had not been properly anchored to its footings; it had slowly crept away from the walls over time and was thus too weak to hold up under the snow. A flurry of lawsuits was filed that took many years to resolve.

Reggie Geare, the young architect who had great early success, found his career in ruins. While officially exonerated by the courts, his design for the Knickerbocker was widely thought responsible for the tragedy. Crandall, who had used Geare for both the Knickerbocker and the Metropolitan Theater downtown, dropped all association with him. As he became unable

to get any new work, Geare grew depressed and was arrested by police for drunk driving in 1926. Then, one day in 1927, after a morning at the office and afternoon playing golf, he returned to his house on Porter Street, NW, and presented his wife a box of candy. He then retired to a little room in the attic, where he turned on the gas and let himself be asphyxiated.

While the Knickerbocker disaster undoubtedly cast a temporary pall over Harry Crandall's business, he was also never found guilty of any wrongdoing in connection with the tragedy, and his most prosperous years were still ahead. In fact, some 1,800 local residents petitioned Crandall to rebuild the Knickerbocker, and within months of the disaster he had committed to do so. The rechristened Ambassador Theater, designed by prominent New York architect Thomas Lamb (1871–1942) and opened in September 1923, retained the Knickerbocker's exterior wall on 18th Street, as well as several interior features that had been left undamaged by the roof collapse.

Crandall continued to open new neighborhood theaters throughout the city. He built the grand Tivoli Theater, for example, located at 14th Street and Park Road, NW, in nearby Columbia Heights, at the same time as he was reconstructing the Ambassador. The Tivoli, also designed by Thomas Lamb, was completed in 1924 at a cost of $1 million, perhaps the most elegant movie palace that Washington ever knew. Throughout the 1920s, Crandall's movie houses continued to flourish, making him one of the city's wealthiest men. He owned a fabulous mansion with a richly paneled library at 16th and Buchanan Streets, NW, where he lived with his wife and three daughters. He was said to be worth $6 million by the time he decided to merge his business with a large national theater chain, the Stanley Corporation, in 1925.

At first, Crandall continued to run his theaters as part of the Stanley organization. But consolidation was sweeping the industry, and by the end of the decade Stanley had merged with Warner Brothers. The coming of the Great Depression hurt Crandall's finances, and he had to sell his remaining interest in the theaters to Warner Brothers. Ultimately, this is what did him in. While outwardly as cheerful as ever, by 1937 Crandall was a broken man. He secretly rented a room in the Parkside Hotel downtown, quietly went there one evening and turned on the gas. When police found his body the next morning, he had left a note of explanation: "You don't have to look for the cause of me taking my life. I'll tell you I have not committed any crime. Have no love affairs. Not insane. Have very good health. No. None of these are the reasons. Only it is I'm despondent and miss my theaters, oh so much."

The Ambassador Theater survived another thirty years and took a decidedly unexpected turn at the very end of its life. Most of the large

old neighborhood theaters were routinely closing in the 1960s, and the Ambassador followed suit in 1966 after the building was sold to developers. The following year, a trio of young music enthusiasts rented the building, cleared the auditorium of seats and most of its decoration, set up colored lights and a new sound system and prepared to open their new Psychedelic Power and Light Company, a far-out nightclub that aimed for a completely different clientele than Harry Crandall had in mind when he built the distinguished Neoclassical building in 1917. Although it was eventually decided to keep the Ambassador name, the *Post* called the club the "wildest, mind-widening, eye-straining, total-involvement dance hall these young men can put together." It was here where Jimi Hendrix (1942–1970), not yet at the height of his fame in America, played for the first time in Washington. This was also the spot in October 1967 where Norman Mailer (1923–2007), Robert Lowell (1917–1977) and others met to launch their famous antiwar march on the Pentagon. However groundbreaking the club may have been musically, it was not a financial success and was closed after about a year. In 1969, the empty old building, now despised by locals as an eyesore, was torn down. After development plans were stymied by neighborhood resistance, the site was sold to the Perpetual Savings and Loan Association, which built a branch bank on it in 1978.

Part VI

HISTORIC SHAW

T he name "Shaw" was coined in the 1960s from the name of a local junior high school, but this neighborhood on the historic northern border of Washington City has deep roots. During the Civil War, military encampments and hospitals first drew people here in significant numbers, both African Americans and whites. Later, in the nineteenth century, as streetcar lines extended north to this area from downtown, residential development began in earnest. In the twentieth century, as the larger city segregated itself into two separate racial worlds, a renaissance of African American culture took hold along the U Street corridor. While much attention has been given to the extraordinary development of arts and entertainment along U Street, there were more mundane businesses thriving in this area as well, such as several large bakeries. And for sporting events like baseball and football, everyone came to Griffith Stadium, for many years one of the few entertainment venues in the city that was racially integrated.

BREAD FOR THE CITY: SHAW'S HISTORIC BAKERIES

Bakeries in what is now known as Shaw were responsible for producing much of the bread, cakes and other baked goods bought by Washingtonians in the early decades of the twentieth century. Brand names such as Dorsch's, Corby's and Holzbeierlein's, all now forgotten, were once staples of Washington households. Even after two national corporations—the Continental Baking

Company and the General Baking Company—took over much of the D.C. market, their baking operations remained anchored in Shaw.

One of the most visible reminders of the neighborhood's bakery heritage is the former Dorsch's White Cross Bakery at 641 S Street, NW, now standing vacant as it waits for redevelopment. This property is just half a block east of 7th Street, NW, Washington's commercial artery one hundred years ago. The oldest section of the building was built in 1913 as an expansion to an existing bakery run by Peter M. Dorsch (1878–1959) at 1811 7th Street, NW. Dorsch had previously worked at bakeries with his younger brothers at various locations in D.C., including K Street in Southwest, Virginia Avenue and Georgetown, before settling on the upper 7th Street site for his own business. Born in D.C., he was the son of a Bavarian immigrant, Michael Dorsch, who had come to Washington in the 1870s and sold imported German foods before opening a restaurant on 7th Street (perhaps where his son later had his bakery). Peter clearly inherited his father's business acumen, and as his White Cross Bakery prospered, he gradually acquired adjacent real estate at the S Street location until his factory became a sprawling complex of retail space, a baking plant and various stables and garages for delivery wagons.

Delivery truck in front of Dorsch's White Cross Bakery in 1923. *Library of Congress.*

Prominent today on S Street are the façades of the buildings Dorsch put up in 1915 and 1922. Both buildings have emblematic white crosses prominently displayed on their pediments. It's surely no accident that the crosses have the same proportions as the American Red Cross's famous icon. At the beginning of the twentieth century, food sanitation had become a nationwide obsession, culminating in Upton Sinclair's influential *The Jungle*, about the horrors of the meatpacking industry. Bread-making was also a topic of concern.[70] An article in the *New York Times* in 1896 excoriated small traditional bakeries in that city ("the walls and floors are covered with vermin, spiders hang from the rafters, and cats, dogs, and chickens are running around in the refuse") and asserted that "the cause of this trouble is that small bakeries are owned by ignorant persons. The large bakeries are conducted in an exemplary manner."[71]

It seems to have been part of a campaign to get people to buy all of their bread from large factories. An 1893 article in the *Evening Star* observed that "[h]ome-made bread is a back number. Machine-made bread takes the cake. The twentieth century bakery is a thing of beauty and the up-to-date baker is a joy forever."[72] At the popular Pure Food Show at the Washington Convention Hall in 1909, D.C. bakeries put on a massive exhibit that filled the K Street end of the hall. Visitors could observe machines doing the work in a modern factory setting; dirty human hands never touched the bread. In that same vein, a 1919 advertisement for Dorsch's in the *Washington Times* urged consumers to give up their old-fashioned reliance on the corner store: "Why buy bread at the grocer's, fresh for each meal, when it is possible to get *good, wholesome*, and *fresh* bread that tastes as good at the *last bite* as it did when you first cut into the warm loaf?"[73]

Dorsch's biggest competitor was the Corby Baking Company, makers of "Mother's Bread," which had its factory just up the street at 2301 Georgia Avenue, NW. Corby's had been founded by Charles I. Corby (1871–1926) and his brother William (1867–1935), who were born in New York and moved to Washington around 1890. Charles started the first small bakeshop on 12th Street, NW, and was soon joined by his brother. In 1894, they borrowed $500 for a down payment to buy a bakery on Georgia Avenue. After construction of a new building in 1902 and additions in 1912, the complex filled much of the block and soon ranked as Washington's largest bakery.

The Corby brothers focused from the start on automation, patenting a number of processes and machines for producing bread of a uniform quality previously unknown. An article in the October 1915 edition of *Baker's Review* marveled at the Corby bakery's high-speed mixers with their

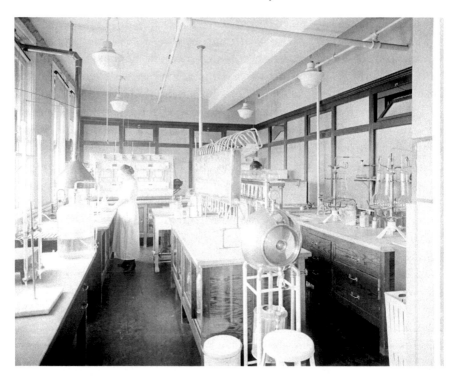

A scene from the modern laboratory of Corby's Bakery, circa 1921. *Library of Congress.*

automatic counters, the dough slides, the six-pocket Duchess dough dividers, the Thomson molders and the Werner & Ffleiderer rounders. At that time, 165 people were on the payroll at Corby's, including 60 bakers. Up to ninety thousand loaves of bread and two and a half tons of cakes were produced each day, and these were sent to the far corners of the District via fifty-two wagon and eight automobile routes, the on-site stables housing ninety-six horses. The self-contained factory had its own power plant, well and refrigerating plant. It even built, painted and maintained its own wagons.[74]

Charles and William Corby both became fabulously wealthy and acquired lavish mansions in Montgomery County. William's sprawling Tudor-style estate at 9 Chevy Chase Circle was called Ishpiming; Charles purchased the Strathmore Hall estate at Rockville Pike and Tuckerman Lane. Charles, who had a heart ailment, fell dead in the grandstands of the Nautilus polo field in Miami Beach, Florida, in February 1926, only a year after retiring from the baking business. His son, Karl W. Corby (1893–1937), who took over after his father's retirement, likewise had heart trouble and likewise died suddenly in February while in Florida.

Not nearly as big as Corby's, Holzbeierlein was located in the same block as Dorsch's, at 1849 7th Street, NW. It was founded by Michael Holzbeierlein, a German immigrant, in 1893. It sold bread and cakes under the "Famous" label and later featured "Bamby" bread. Like Dorsch, Holzbeierlein had his retail bakery on 7th Street and larger baking and distribution facilities nearby, on Wiltberger Street. A newspaper advertisement from 1908 included this charmingly vapid jingle:

> *Famous Bread and famous Cake,*
> *Famous everything they make;*
> *That's the motto and the sign*
> *Of the famous HOLZBEIERLEIN.*

The Holzbeierlein business remained family-owned throughout its history. It declared bankruptcy in 1953, unable to compete with low-cost national brands. It had seventy employees and thirty delivery trucks at the time it folded.

National brands began taking over the Washington market as early as 1911, when the General Baking Company was formed in New York City by merging prominent bakeries from all over the East Coast and the Midwest. In Washington, the Boston Baking Company joined the new conglomerate and began producing Bond Bread in its bakery at the foot of Capitol Hill. By 1928, government plans to relocate the U.S. Botanical Gardens to that site forced General Baking to find a new location, and company officials chose Shaw.

The site chosen was located on Georgia Avenue about a block and a half south of the Corby bakery complex. Excavation work at the bakery site began in 1929 for the $650,000 state-of-the-art building, designed by C.B. Comstock of New York, an experienced bakery architect. It was completed in 1930.

Of all the historic Shaw bakery buildings that remain standing, the Bond Bread Building is the most distinctive. At a time when many new factory buildings were nondescript, the General Baking Company clearly sought a distinguished look for its Georgia Avenue plant. The brick-and-concrete building's stepped, three-level façade is in keeping with Art Deco design practices, which favored ziggurat-like shapes. Its sleek vertical piers with their pointed stone caps at the roof-line signal a touch of the soaring optimism of the Art Deco age, though the building is not actually very tall. The design adheres to the "stripped classical" or "traditionalized Moderne" style typical of federal Washington—the verve of Art Deco checked by the constraints of Neoclassicism.[75] The main entrance, for example, is purely Neoclassical and

could work as well on a bank as a bread factory. The overall message, though restrained, is of pride and permanence.

By moving to this location, General Baking was squaring off directly with its biggest rival, the Continental Baking Company, which had taken over the Corby bakery in 1925. Continental replaced Corby's Mother's Bread with its new Wonder Bread product, which was rapidly gaining in popularity. In October 1925, the company, still using the Corby's name, advertised "a delicious new Cake Dedicated to the women of the nation's Capital! In homage to them named Hostess Cake!" It's not clear where the Hostess name actually originated, but it soon became the brand for all of Continental Baking's cake products. The company further expanded by buying Dorsch's White Cross Bakery in 1936, giving it a combined capacity at its two locations of 200,000 loaves of bread each day. It seems likely that by the 1940s, the company made Wonder Bread primarily at the former Corby's Bakery and Hostess Cake products at the White Cross site.

The 1930s saw bread marketing begin to shift away from sanitation fears and focus more on nutritional benefits. General Baking upped the ante in 1931 when it licensed patents for fortifying its Bond Bread with vitamin D, the sunshine vitamin. Continental responded by adding even more nutrients to Wonder Bread, eventually culminating in the famous "Builds Strong Bodies 12 Ways" slogan. In 1973, the Federal Trade Commission barred ITT Continental Baking from running ads that implied that Wonder Bread was more nutritious than other bread or could spur growth in children.

Wonder Bread continues to be produced, of course, now by Hostess Brands, Inc., which bought Continental Baking in the mid-1990s. The former Corby complex was shut down in 1988 when Continental Baking decided to consolidate regional operations in a larger, newer facility in Philadelphia. In 1990, the company sold the Corby complex to developer Douglas Jemal, who converted the old bakery buildings for retail and office use. Howard University then purchased the Wonder Plaza complex in 1993 for $18.3 million. Jemal also purchased the former Dorsch's White Cross Bakery, complete with bright "Wonder Bread" and "Hostess Cake" lettering on its historic façade. The property has come to be known as the Wonder Bread Factory.

Meanwhile, the fate of the Bond Bread Building hangs in the balance. In the 1960s, General Baking Company's profit margins slimmed to the point where bread-making was no longer profitable. The company renamed itself General Host in 1967 and gradually shuttered its bakeries to concentrate on other forms of retail. By 1971, the Georgia Avenue plant

had shut down and was purchased by the D.C. government for use as a community services center.

The 1971 arrangement provided the District with federal funds to renovate the old bakery and run the community services center in it jointly with the People's Involvement Corporation, a federally financed antipoverty group that was given a thirty-year tenancy. Mayor Walter Washington verbally promised PIC that it could take ownership of the building at the end of that period, but by 2001 the District had other plans. Specifically, the D.C. government proposed giving the property to Howard University, which planned a development there called Howard Town Center, a mix of housing and retail. In exchange, the university would give the District a parcel at Florida and Sherman Avenues, where a separate project of offices, retail and housing would be developed. PIC sued to gain ownership of the building based on the mayor's original promise, but it lost in court. Meanwhile, the deal with Howard was ratified by the city council in 2006 and completed in 2008. Howard has secured a developer that reportedly plans to demolish the handsome old Bond Bread Building as soon as an anchor grocery tenant can be found for its new Howard Town Center complex.

BASEBALL AT THE ECCENTRIC GRIFFITH STADIUM

Right across the street from the Bond Bread Building once stood Griffith Stadium, the home of professional baseball—and later football—in Washington for many years. Attendees at ballgames would be treated to the sweet smells of the Bond Bread factory wafting over them as they sat in the stadium's bleachers, just one of the quaint and charming aspects of old Washington life that have vanished from the capital forever.

Baseball has a long history in Washington. The first team, called the Nationals, was organized by a group of government clerks in 1859. It opened its 1865 season with a game against the 133rd New York Volunteers, a Union army regiment that was passing through on its way home from Appomattox, its war duties over. After the war, President Andrew Johnson reportedly attended baseball games at the "White Lot" located just to the southwest of the White House.[76]

In addition to establishing a tradition of not being very good, early Washington teams bounced around among a number of ballparks, such as Athletic Park at 9th and S Streets, NW—said to be not much more than a muddy field and some wooden bleachers—and Capitol Park, located

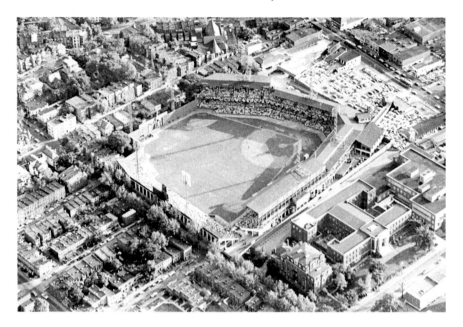

Aerial view of Griffith Stadium. *National Baseball Hall of Fame.*

roughly where Union Station stands today and also fairly rudimentary. The booming real estate market in the late nineteenth century inevitably caused landowners to evict ball clubs and sell to developers.

In 1891, a patch of land forested with more than one hundred stately oak trees was cleared for a new ballpark, and unlike the other sites this one was to remain a sporting venue for seventy years. The plot of land was literally on the edge of town, just north of Boundary Street (present-day Florida Avenue) and maybe half a block east of Georgia Avenue, which, as the 7th Street Road in the nineteenth century, was one of the few roads leading into the city from the north. During the Civil War, a hotel, called the Maryland House, had been built at this spot to accommodate travelers, and it eventually became part of Breyer's Park, an early resort with a bowling alley, a dancing pavilion and a racetrack. The new ballpark was originally built next to these facilities but eventually took over the space as it was remodeled and expanded. By the 1890s, this location was ideal because it was easy to reach via streetcar up 7th Street from downtown or across Florida Avenue.

The *Washington Post* declared in March 1891 that this new National Baseball Park featured "the finest bleachers ever seen in Washington. There are rows of seats and places for the people to rest their feet without getting them against the backs of the people in front," which presumably had been

a problem with previous stadiums. Washington teams came and went in the 1880s and 1890s. In 1891, they were called the Statesmen, and later that year they joined the new National League.

A colorful story, much embroidered over time, has been told about the so-called Ladies' Day Riot. Ladies' days, when women were admitted free, were a common occurrence, and one particularly memorable one was held in September 1897. It was the penultimate game of the season, and the Washington team, called the Senators at this point, were facing the Cincinnati Reds. The Reds won, 2–1, after umpire Bill Carpenter "gave" them the game by walking a Reds player who had clearly (at least, in the eyes of Washington fans) struck out. The Senators' pitcher was a certain heartthrob by the name of George "Winnie" Mercer (1874–1903), supposedly the main reason for the presence of so many enthusiastic women on Ladies' Day. Mercer responded to the offending call with a bit of crowd-pleasing showmanship, gallantly pulling a pair of glasses out of his pocket and offering them to Carpenter to improve his eyesight. This, of course, enraged the umpire, who promptly benched Mercer, and that in turn enraged all of Mercer's numerous female admirers. Stories claim that angry female fans descended onto the field at the end of the game and attacked Carpenter, tearing his clothes. They also supposedly tore up seats and broke at least one window. The *Post* makes no mention of any of this mayhem, but the *Baltimore Sun* noted that when Carpenter left the field,

> *he was hurried into the baseball office in the rear of the stand, and there he was besieged by the female enthusiasts, who beat upon the closed shutters with their parasols and umbrellas and screamed vengeance. Finally the unhappy umpire had to be smuggled out of the grounds through a side gate to escape the crowds of women who waited for him at the regular exit.*[77]

Despite his good looks and popularity, Mercer was a troubled young man suffering from a serious pulmonary condition; he took his own life in San Francisco in 1903.

Meanwhile, after the Washington team had been disbanded by the National League in 1900 and then reestablished in the new American League in 1901, it settled in at National Park, now rechristened American League Park, and its glory days began. Likely the greatest pitcher to ever play the game, mild-mannered Walter "the Big Train" Johnson (1887–1946), joined the team—known variously as the either the Nationals or the Senators—in 1907. In his twenty-one years with the Senators, Johnson

set astonishing records, some of which remain unbroken. Despite being a member of a team of mostly middling players, Johnson brought many wins to the Senators. He led the league in strikeouts twelve times, striking out a peak total of 313 batters in 1910, and reaching a staggering total of 3,508 over his full career. He continues to hold the all-time record for shutout games, at 110. Johnson's achievements came from his powerful throw. He was discovered by a Senators scout in Idaho, throwing pitches that were "so fast you can't see 'em." His fastballs were so overwhelming that he never needed to develop other pitches.

In March 1911, only weeks before the start of the new season, a catastrophic fire swept through American League Park, destroying it. The midday fire was set off by a plumber's blowtorch and couldn't be doused because the plumbers had shut off the water. The wooden grandstands, a nearby lumberyard and the former Freedman's Hospital building next door all went up in smoke. Nevertheless, the ball club vowed to have new concrete and steel stands erected in time for the opener on April 12, with a completely new stadium to be finished the following month, "one of the most modern and convenient grand stands in the South." Among the sixteen thousand fans who showed up for that opening game was President William Howard Taft, who, with great fanfare, threw out the first ball to Washington pitcher "Dolly" Gray, thus initiating a tradition that, with minor modifications, has continued to the present. The Nats also, helpfully, won that day, beating Boston 8–5.

The following year, a former twirler by the name of Clark "the Old Fox" Griffith (1869–1955) came to Washington to be manager of the Senators, and he set to work building a potent team around star pitcher Walter Johnson. The team immediately improved, placing second in 1912 and 1913. Griffith developed a reputation for making the most out of what he had—and for being stingy in investing in the team's long-term future. Griffith would continue as manager until 1920, and subsequently as owner until his death in 1955. During these many years, the Senators were actually only in last place six times, despite the famous quip that Washington was "first in war, first in peace, and last in the American League."

Griffith extensively remodeled and expanded American League Park in 1923, increasing its capacity to fifty thousand and naming the new structure Clark Griffith Stadium. His $110,000 investment was designed to broaden the utility and appeal of the stadium so that it would be leased out for all sorts of sporting events. A new football scoreboard was installed to support special events such as the Army-Marine game, as well as local team events,

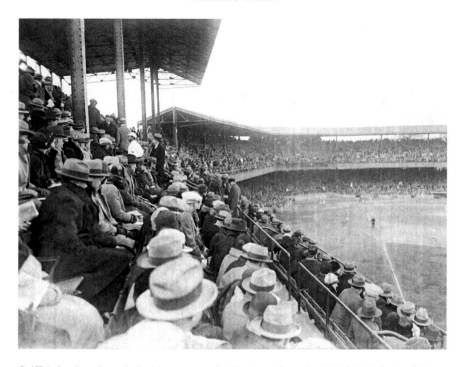

Griffith Stadium is packed with spectators in this photo from the 1925 World Series. *Library of Congress.*

although it would be another fourteen years before a Boston football team called the Redskins moved to Washington and began playing their home games at Griffith Stadium. Meanwhile, Georgetown University signed up to play all its home games at Griffith.

Having been slowly built up over time to fill out the land available to it, the stadium was never a thing of beauty. Famously, the right outfield fence veered inward eccentrically to avoid a cherished oak tree and five neighborhood row houses. Different sections of the grandstands ended up at different heights, depending on when they were constructed. The slightly oblong outfield was one of the largest in the game at 405 feet to left field and as much as 457 feet to center.[78] Residential construction had filled the lots all around the stadium so that it ultimately appeared wedged in among them from the air. Concrete walls as tall as thirty-one feet kept the neighbors out but also formed dangerous obstacles for players, who collided with them in pursuit of a fly ball or line drive. Such was the fate of the great George "Babe" Ruth (1895–1948), who was playing with the Yankees against the Senators on a hot July day in 1924. Ruth went after a long foul ball hit by Joe

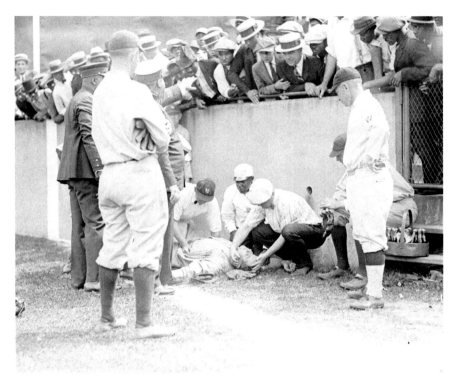

Babe Ruth lies unconscious by Griffith Stadium's concrete east wall in July 1924. *Library of Congress.*

Judge that ended up in the stands. In doing so, he collided with the concrete wall and knocked himself unconscious. Once he came to, he insisted on staying in the game. The Yanks won that game 2–0, but the Senators were already leading the league that year. They would go on to beat the New York Giants in the World Series, the only time Washington ever won the series.

While almost all forms of public entertainment were segregated in Washington in those days, Griffith Stadium, at least officially, was not. Although there were no signs designating white and black sections, everyone understood that African Americans were supposed to stay in their own area behind right field, right around where Babe Ruth knocked himself out. And despite Clark Griffith's refusal to add nonwhite players to the Senators, African American fans were numerous and loyal. When the Senators weren't playing, the stadium was often rented out for a variety of local events that catered to the African Americans who populated the surrounding neighborhoods. Most notably, in the 1940s the Homestead Grays, a Negro National League team that was one of the finest professional baseball teams

ever assembled, played at Griffith Stadium, where they far outclassed the abysmal Senators of that era.

The team included five players who would eventually join the Baseball Hall of Fame: James "Cool Papa" Bell (1903–1991), Ray Brown (1908–1965), Josh Gibson (1911–1947), Walter Fenner "Buck" Leonard (1907–1997) and Jud "Boojum" Wilson (1894–1963). Gibson, known as the Black Babe Ruth, was a powerful hitter known for his many home runs (statistics for players in the Negro leagues are difficult to establish because records were not kept in the same way as the major leagues and playing schedules were not comparable). Gibson is credited with hitting two of the only three homers to ever make it all the way across the long left outfield of Griffith Stadium and out of the park. Mickey Mantle (1931–1995) hit the other one in 1953, getting credit for the longest home run in baseball history at 565 feet. Buck Leonard, who became a hero for local African Americans, was called the Black Lou Gehrig, and his batting was close to Gibson's. He is credited with earning a .391 average in 1948, his best season, and having a .341 career average with the Grays.[79] The superb playing of these superstars drew sell-out crowds, mostly of African Americans, and may have indirectly helped keep the anemic Senators of this period afloat.

After Clark Griffith's death in 1955, control of the Senators shifted to his nephew, Calvin Griffith, who immediately began planning to get the team out of Washington. He did so in 1960, moving the team to Minneapolis, but a new expansion Senators baseball team took its place in D.C. the following year. By now, the quirky old Griffith Stadium was woefully out of date, and a new D.C. stadium, designed as a multipurpose (but primarily for football) facility, was completed at 2400 East Capitol Street, SE, in 1961. Later to be renamed the Robert F. Kennedy Memorial Stadium, it became home to the new Senators team in 1962. Meanwhile, Griffith Stadium stood empty and overgrown with weeds for several years before Howard University acquired it and tore it down in 1965. Howard University Hospital now stands on the site.

Part VII

UPPER NORTHWEST

Farm roads and country estates had dotted the landscape of upper northwest Washington since the city's earliest days, along with little hamlets such as Tenallytown along the turnpike that headed out to Rockville. The hilly terrain and other natural barriers, such as the deep valley of Rock Creek, prevented higher-density urban development until the early twentieth century. A key turning point occurred in the 1880s when Francis G. Newlands (1846–1917) and his partners began buying up property in anticipation of the extension of Connecticut Avenue from Kalorama Heights to the Maryland border. The Chevy Chase Land Company, formed by the group, overcame numerous obstacles to construct the road in the early 1890s and also built a streetcar line to run its entire length. In 1907, the D.C. government completed the grand, concrete-arched bridge that now carries Connecticut Avenue over the Rock Creek valley, making upper Connecticut Avenue easily accessible. The Wardman Park Hotel was an early result of these developments. Twenty years later, Connecticut Avenue was an established commuter artery connecting numerous residential communities with downtown Washington. Shopping and entertainment centers like the Chevy Chase Ice Palace and Sports Arena were designed specifically with the automobile-bound commuter in mind.

Harry Wardman's Original
Wardman Park Hotel

The Wardman Park Hotel—now called the Marriott Wardman Park—sprawls over a commanding hillside in northwest Washington just off Connecticut Avenue in Woodley Park. At one end of the hotel complex, closest to the avenue, stands an elegant, historic tower section, built in 1929. But this old tower was not the original Wardman Park. That building, torn down in 1979, goes back to the early days of Woodley Park when its construction was a feat of exceptional audacity.

The story begins with Harry Wardman (1872–1938), perhaps Washington's greatest real estate developer, who by the time of his death had built four hundred apartment buildings and five thousand houses throughout Washington.[80] Wardman was born in Bradford, England, the son of textile workers. At age seventeen, he decided to stow away on a ship bound for Sydney, Australia, but was discovered and put ashore—supposedly with just seven shillings in his pocket—when the ship stopped at New York City. He found a job as a salesman for John Wanamaker in Philadelphia, where he also bought a set of carpenter tools and learned how to build stairways.

Wardman moved to Washington in 1897 and first lived near the Franciscan Monastery in Brookland, bicycling to work as a carpenter with his tools strapped to the handlebars. His big break in real estate came when he hooked up with a tailor named Henry Burglin, a fellow Englishman, to build a row of frame houses at 9th and Longfellow Streets, NW, in the then suburb of Brightwood. Wardman and Burglin each made $5,000 on the deal, and Wardman used his profits to launch his real estate empire. He was soon building houses throughout the city.

The first large Wardman landmarks—the Dresden Apartments at Connecticut Avenue and Kalorama Road, NW, and the Northumberland Apartments at New Hampshire Avenue and V Street, NW, both constructed in 1909—were designed by Albert H. Beers (1859–1911), a successful architect from Bridgeport, Connecticut, who came to Washington in about 1903. In addition to forty-seven apartment buildings and hundreds of townhouses, Beers also designed Wardman's palatial Spanish-style mansion home, a grand, white-stucco villa with green-tiled roof that once stood at the corner of Connecticut Avenue and Woodley Road. In addition to perching this ostentatious mansion atop the rocky hill at Connecticut and Woodley, Wardman began constructing large apartment buildings and rows of townhouses throughout the emerging "suburb" of Woodley Park.

After architect Beers had died unexpectedly from pneumonia in 1911, Wardman had many of his buildings designed by Frank Russell White (1889–1961), a native of Brooklyn who had come to Washington as a young man in 1909. White was on hand when, in 1916, Wardman acquired a large tract of land along Woodley Road and immediately began planning a massive new development. Originally to be called Woodley Court, it was conceived as a large circular complex of apartment houses.[81] But by the time construction began in 1917, plans had changed dramatically. Instead of apartment buildings, Wardman constructed the largest hotel the city had ever seen and one of the biggest in the country.

While designing the immense new hotel in Woodley Park, White was also simultaneously working on several other substantial apartment buildings for Wardman, including Somerset House at 16th and S Streets, NW, and the stately Northbrook Court, at 16th and Newton Streets, NW, with its commanding stone balconies. For the new eight-story Woodley Park hotel, White laid out a spoked horseshoe design, allowing for plenty of sunny exposures, and clothed it in a red-brick Colonial Revival façade patterned after the Homestead resort hotel in Hot Springs, Virginia.

The Homestead was a longtime favorite of Wardman's, and he clearly wanted his new hotel to be seen as both luxurious and convenient. (He hired the Homestead's manager, Henry Albert, to run the Wardman Park.)

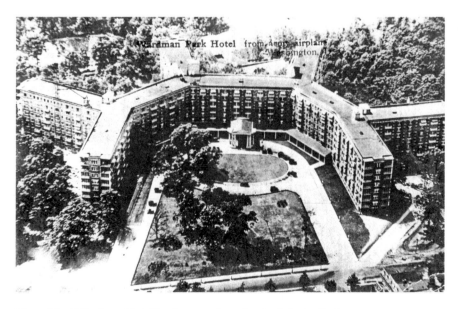

The original Wardman Park Hotel as seen from the air. *Author's collection.*

The 1,200-room residential hotel had balconies for each suite and private baths for every bedroom. Only about 200 of the rooms were designated for transients; the others could all be connected into suites of various sizes to accommodate any resident's needs. Originally painted a dignified French gray, the hotel's public areas included a six-hundred-seat dining room and an elaborate lounge with dance floor. There was a Turkish bath in the basement, a billiard room, a drugstore, a barbershop and even a post office. A three-level parking garage, accommodating five hundred automobiles, was a strikingly modern amenity. The hotel cost $5 million to build and was called "Wardman's Folly" when it was under construction because people thought it foolish to build such a huge facility so far out in the suburbs.

In fact, the hotel was a tremendous success. When it was opened in November 1918—in the midst of a wartime housing shortage—all of its rooms were immediately occupied, and there was a long waiting list for the section of the hotel that had not yet been completed. Important guests included Vice President Thomas R. Marshall and his family, several cabinet members, congressmen and a variety of high-level diplomats from around the world.

It was at the old Wardman Park that poet Langston Hughes (1902–1967) famously got his first big break in the mid-1920s. Hughes was a busboy working in the dining room one evening when Vachel Lindsay (1879–1931), an American poet popular in the early twentieth century, was having dinner. Hughes slipped a few of his poems onto the table for Lindsay to read. Though annoyed at first, Lindsay read the poems and appreciated the talent they demonstrated. He introduced the young poet to publishers who soon brought out volumes of his work.

As Washington's most prolific developer, Wardman was always moving on to something new, taking the profit from his last effort and investing it all in new projects. In 1928, just a year before the start of the Great Depression, Wardman was going great guns. He had previously considered razing his own mansion for the construction of the original Wardman Park Hotel in 1916, and now that his second wife, Lillian Glascox Wardman (1889–1975), was conveniently in Europe overseeing the education of their daughter, he decided to go ahead and tear down the house to build a luxury annex for the hotel. The new 350-room cross-shaped Annex, costing $2 million, was even more luxurious than the original hotel. The architect was Mihran Mesrobian (1889–1975), who had designed the Carlton Hotel on 16th Street in 1926 and the Hay-Adams Hotel a block south of it in 1927. In keeping with Frank White's original design, the new annex was red brick and Colonial Revival in style, although more ornate than the main hotel

Mrs. Lillian R. Wardman was in Europe with her daughter when her husband, Harry Wardman, decided to tear down their magnificent Spanish-style mansion and replace it with an annex to the Wardman Park Hotel. *Library of Congress.*

building. It contained large suites intended exclusively for wealthy long-term residents. These suites included an entrance hall, a living room, a formal dining room, a kitchen with butler's pantry and multiple bedrooms, libraries and dens. The annex would become home to many of Washington's rich and powerful, including presidents, vice presidents, senators, congressmen and cabinet secretaries. The high level of service available from the hotel kept it an appealing prestige address for decades to come.

In 1928, the same year the annex was started, newspapers reported that Wardman was once again raising capital—$11 million this time—by floating a bond issue, essentially mortgaging his apartment and hotel properties. It proved to be Wardman's undoing. The financial crisis that ignited the Great Depression struck the following year, and in 1930 Wardman was forced to sign away all of his major properties, including the Wardman Park complex. His last major project, completed that year, was the British embassy on Massachusetts Avenue.

Wardman had always been a gregarious man, "happiest when surrounded by a crowd," as described by Carl Bernstein in a 1969 *Washington Post* article. "An avid baseball and prize fight fan, he made a practice of hiring private cars for big fights and transporting a coterie of formally attired friends

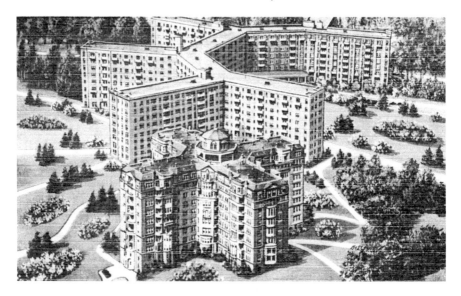

The 1929 Wardman Park Annex is seen in the foreground of this postcard view, with the original hotel behind it. *Author's collection.*

and diplomats to the pugilistic wars, then back to [his great mansion at] Woodley Road for a ball."[82] Like the mansion itself, all of that was gone in the 1930s. To make matters worse, Congress attacked Wardman's exuberant developments, blaming him for having "overbuilt" Washington. Questioned about charges that the bonds issued for his company were based on inflated property values, Wardman claimed that he knew nothing about it. "I did the building work," he said, "and signed the papers when they were put before me. All that stuff was foreign to me." Asked if he planned to rebuild his empire, Wardman said, "No sir, I'm through with that. I thought I was a rich man and then I woke up and found I didn't have a nickel." Nevertheless, he still owned a number of house lots and continued building houses until the time of his death, at sixty-five, in 1938.

The Wardman Park hotel changed hands but remained popular as a residence, especially with the well-to-do. When the Sheraton Hotel chain purchased it in 1953, its emphasis began to change toward transient guests and conventions. In 1973, the hotel's corporate owners announced that they wanted to tear it down and replace it with a new ten-story structure that would have larger spaces for banquets, meetings and convention exhibits. Oblivious to the benefits of adapting and restoring the historic 1918 structure, the Sheraton officials stressed that their new convention hotel would bring economic benefits to the city. They also said they would

keep the beautiful annex, now called the Wardman Tower, that had been completed in 1929. For some, that seemed to compensate for destroying the original building, which had not been historically designated. Woodley Park residents opposed the plan but focused their objections mostly on how the new building would affect the community—increased traffic, inadequate parking, violations of height limitations and so on. The company dealt with these objections and proceeded with its plans. After the new hotel—designed in a featureless modernistic idiom by Hellmuth, Obata & Kassabaum—was built next to it, the old hotel was torn down in 1979. First called the Sheraton Washington, its replacement is now operated by the Marriott chain and called the Marriott Wardman Park.

THE CHEVY CHASE ICE PALACE

According to an advertisement in the *Washington Post*, it was "one of the largest parking and shopping units in the country" when the Chevy Chase Ice Palace and Sports Center opened in 1938 on upper Connecticut Avenue.[83] As strip malls go, the building, which still stands in the 4400 block of Connecticut Avenue just north of the Van Ness Metro stop, now looks rather small, but when it was opened it was a marvel of modern engineering and retail convenience.

In 1938, this part of the city was well on its way to transitioning from a lightly populated "suburb" within the District to an urban residential zone. The avenue had been zoned in 1920 such that most of it was to be lined with medium-density apartment buildings. At regular intervals, single blocks were designated for commercial development. The 4400 block was one such commercial zone.

Developer Garfield I. Kass (1890–1975) saw a great opportunity at this location, despite the difficult site that sloped steeply from street level down to a tributary of Rock Creek in the valley below. There was pent-up demand for shopping from local residents that did not have other options in their neighborhood. Beyond that, "park and shop" centers like this one were hot commodities in the 1930s, after the successful development in 1930 of the Park and Shop center just down the street in Cleveland Park. Kass had already developed park and shop centers in the Rosslyn and Clarendon neighborhoods of Arlington County, Virginia, and another at Georgia Avenue and Rittenhouse Street, NW, in Shepherd Park. Situating such centers along main commuting arteries—on the same side of the street as the evening, homeward-bound traffic—was sure to make for substantial profits.

The Chevy Chase Center was indeed larger than any of these previous local developments. The building was designed by James F. Hogan, Kass Realty's staff architect, in the fashionable streamline Moderne style. The elongated 345-foot blond-brick façade is striated by lines of dark brick, giving it an energetic, almost jazzy feel. In contrast, towerlike elements at the building's corners have jagged brickwork and vertical lines, adding to the sense of energy and machine-age progress. Beneath these second-floor design embellishments, the building's ground floor was originally a lively sprawl of storefronts embracing the front parking lot.

When the complex opened, it had everything: an ice skating rink, forty-one maple-wood bowling alleys and an assortment of retail stores including F.W. Woolworth's five-and-dime store, an Atlantic & Pacific grocery store, Best & Company clothiers and a People's Drug Store. The ice skating rink, which hadn't been mentioned when plans for the complex were announced in 1937,[84] turned out to be the jewel in the crown. Advertised as the first indoor ice skating rink in Washington (though, in fact, one had been in operation previously in the old Convention Hall downtown), its sheet of ice was kept frozen by a massive seven-mile-long array of welded tubing that circulated supercooled brine water pumped from coolers in rooms underneath.

Postcard view of the Chevy Chase Ice Palace and Sports Center around the time it opened in 1938. *Author's collection.*

On opening day, 2,200 people hit the rink, raking in $4,000 in profits for Kass Realty. The *Post*'s Jack Munhall surveyed the crowd and observed, "Flashing their shining blades to the swaying rhythm of waltz time flung out over the public address system these enthusiasts of the skim and glide sport jammed the rink to capacity."[85] The Ice Palace soon hired champion skater Norval Baptie (1879–1966) as its chief ice skating instructor. Canadian-born Baptie had been world champion speed skater for some thirty years before staging elaborate ice shows at Madison Square Garden in New York City with the likes of Sonja Henie (1912–1969). At age fifty-nine, he was settling in to a somewhat less demanding routine at the Chevy Chase Ice Palace. As an added draw, pretty DeLories Zeigfeld (1914–1989), niece of Broadway impresario Florenz Zeigfeld, was also taken on as an instructor. Zeigfeld was only twenty-three but was an experienced professional with a recognizable name. The duo helped the ice palace attract steady crowds.

The existence of the Chevy Chase Ice Palace did wonders for the popularity of ice skating in the city. A number of skating clubs formed, many composed of workers at local businesses or federal agencies. These clubs got reserved times for exclusive skating. In 1941, the ice palace adopted a policy of offering free admission and skate rental to all servicemen. The 1940s ended up being a golden age for Washington ice skating. According to the *Evening Star*, the Washington Figure Skating Club won awards for the most points in national championships in 1946, 1948 and 1950.[86]

In addition to the ice skating rink, which filled the large second-story floor space above the street-level shops, the building had a number of below-grade floors. It had been built into a steep hillside, with its footings resting on bedrock forty to fifty feet below Connecticut Avenue. Several lower floors held the bowling lanes, as well as space for pool tables and ping-pong tables. The center thus also became a venue for regional championship table tennis in the 1940s.

In the end, however, the indoor sports gravy train did not last long on Connecticut Avenue. The indoor ice skating rink was closed in 1950 when the Evening Star Broadcasting Company, operators of WMAL-TV, leased the second-floor space for use as a broadcasting center. Three TV studios were constructed in the space formerly occupied by the rink. Over the years, the WMAL studios were used for a number of historic broadcasts, including Ruth Crane's pioneering series *The Modern Woman* and the much-loved children's show *Claire and Coco*, as well as *Town and Country Time*, a variety show hosted by young country/western singer Jimmy Dean (1928–2010), who gained fame for his singing in the 1950s and for his pure pork sausages

in the decades following. On March 23, 1956, Dean had as a guest on his show a nervous young singer named Elvis Presley, then just coming into his own.[87] Presley was one of many entertainment personalities who made stops at the Connecticut Avenue broadcasting complex.

WMAL, the predecessor of WJLA-TV, was on Channel 7, and a large neon sign would flash across the front of the building at night "7…7…7… Good Looking!" The gaudy sign was especially noticeable as one came out of the Hot Shoppes restaurant across the street, perhaps after enjoying some delicious Pappy Parker's fried chicken.

In 1988, WJLA moved to the Intelsat Building several blocks south. The owners of the old building then embarked on an extensive renovation and remodeling of the space, adding to the façade two boxy towers containing elevator shafts that broke up its sleek Art Deco lines. Since reopening, the building has been used as a mixed office and retail complex known as Van Ness Square.

Part VIII

UPPER NORTHEAST

L ike the northwest, the upper northeast section of the District of Columbia
was largely rolling farmland and rugged wilderness one hundred years
ago. It was up through this countryside that Abraham Lincoln used to ride
in the summer to escape the stagnant, unhealthy air of Washington City
and relax at his cottage on the grounds of the Soldiers' Home. But more
than anything else, the character of the upper northeast was the defined
by the arrival of the Baltimore & Ohio Railroad in 1835. The railroad
changed everything in its path, ruining the future prospects of the once
grand Brentwood estate but at the same time opening up possibilities for
new developments, such as the suburb called Takoma Park.

THE BRENTWOOD ESTATE AND CAMP MEIGS

Boundary Street, now Florida Avenue, marked the furthest extent of the
gridded and relatively flat town of Washington City in the nineteenth
century. Across the street, hills loomed into the distance, nestling among
them a few scattered farmhouses and country estates. One such estate was
Brentwood, located atop a gently sloping hill east of Boundary Street and
New York Avenue, where it offered dramatic views of the city to the south
while being only a short carriage ride away. "There is no one spot near the
city from which a better view can be obtained," proclaimed the *Washington
Post* in 1915.

The property on which Brentwood was built was originally part of the substantial holdings of Notley Young (circa 1736–1802), one of the eighteen original proprietors of the land that would become the District of Columbia. Young's daughter, Mary, married Robert Brent (circa 1763–1819), the first mayor of Washington, and the couple inherited the estate on which Brentwood would be built. Brent was born into a wealthy family in Stafford County, Virginia, who controlled the nearby Aquia sandstone quarry. Stone from the quarry was used in many early government construction projects, including the Capitol and the White House. Robert Brent was asked by Thomas Jefferson to be the first mayor of the new federal city, and though reluctant to take on this burden, Brent rose to the challenge and served with distinction for ten years, establishing key functions such as the first police and fire departments and never accepting payment for his services.

In 1817, Brent began construction of the Brentwood mansion. There is strong evidence that the architect was the great Benjamin Henry Latrobe (1764–1820), although some scholars have doubts.[88] Whoever designed it, it was elegant, distinctive and built for entertainment. The stately, two-story Greek Revival mansion, faced in stucco (as was fashionable in those days),

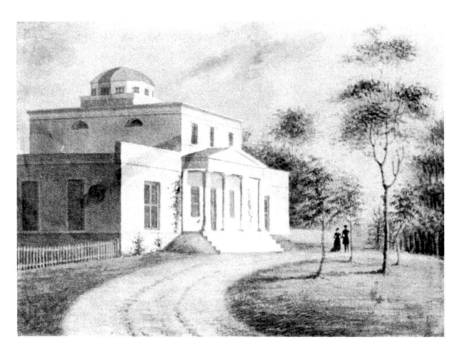

A drawing of the Brentwood mansion in its early days. *Records of the Columbia Historical Society, Vol. 2 (1899).*

had two long single-story wings at its sides. At its core was a great, domed central hall, rising the full two stories of the house and with a cupola on top to allow in natural light. Dining and reception rooms adjoined it on three sides. It was to be the site of many an elegant fête through much of the nineteenth century.

Robert Brent never had a chance to live at Brentwood. Though partially paralyzed from a stroke, he visited the construction site in 1818 and also oversaw the erection near the house of an elaborate Egyptian Revival mausoleum, where he was buried after his death in 1819. It was Brent's daughter, Ellen, who moved in with her husband, Representative Joseph Pearson (1776–1834) of North Carolina, when the house was completed. The couple began the tradition of gracious entertainment and hospitality for which Brentwood soon became well known. A Pearson daughter, Elizabeth, married Captain Carlile P. Patterson (1816–1881), a naval officer and fourth superintendent of the United States Coast Survey, in 1851 in the central hall of Brentwood, and the Pattersons continued the Brentwood tradition of refined living.

After Carlile Patterson's death, however, the property began a long period of decline. In 1889, Patterson's son-in-law, Francis Winslow, took over management of the estate and focused on leasing or selling various portions. The railroad that had snaked down along the northwest side of the property since the 1830s had become a heavily trafficked commercial artery, and part of the estate was sold to the railroad for expansion of its freight yards. What had once been an isolated and restful retreat grew undesirable as a residential enclave. By the end of the century, the old mansion stood empty and disused, quietly tended to by a caretaker but slowly falling apart.

A photograph of the once stately mansion, decaying and choked with overgrowth, was used by the famed African American poet Paul Laurence Dunbar (1872–1906) to illustrate a poem called "The Deserted Plantation." While not specifically a description of Brentwood, the poem's romantic lines seem to capture the spirit of the abandoned house:

> *An' de big house stan's all quiet lak an' solemn,*
> *Not a blessed soul in pa'lor, po'ch, er lawn;*
> *Not a guest, ner not a ca'iage lef' to haul 'em,*
> *Fu' de ones dat tu'ned de latch-string out air gone.*[89]

In 1911, an intrepid reporter for the *Washington Herald* passed locked gates and growling dogs to inspect the abandoned house, noting water damage

in the central hall, fallen plaster in several other rooms, a cracked marble mantelpiece and battered mahogany stair rail.[90] Desolation had replaced elegance. Inevitably the spooky old place was thought to be haunted, and tales were spread that jewelry and gems were buried somewhere on the premises. One tale mentioned in the *Post* was that gold was hidden at the mansion during the Civil War. As unlikely as these stories might be, they motivated vandals to break in and thoroughly ransack the house one day in 1915, tapping on walls, pulling out wooden mantels and prying open old trunks. Apparently, they didn't find what they wanted, because the thieves returned six weeks later and broke into the brick mausoleum that held Robert Brent's and other family members' remains. Heavy slabs were removed from the tombs, caskets broken open and bones tossed about in search of secret treasure. The "ghouls," as they were called in the press, were never apprehended. The human remains were reinterred at other cemeteries, and the empty mausoleum was sealed up. The mansion's final indignity came just after Christmas that same year, when it was largely destroyed in a fire that may have been the result of the caretaker's son throwing an impromptu holiday party in the old hall. There was little left of it after that, although parts of the house still stood in ruins as late as 1923.

After the onset of World War I, much change came to this area, as it did to the rest of the city. The tract of land stretching from the house on top of the hill down to Florida Avenue was taken over by the Army's Quartermaster Corps to create Camp Meigs, a logistics staging ground for the war effort in Europe. When it was opened in October 1917, Camp Meigs had eighteen barracks, six mess halls, several administration buildings and a hospital. Its objective was to assemble expert tradesmen from around the country into military units and then send them overseas for duty. Carpenters, auto mechanics, machinists, ironworkers, electricians—they all went through Camp Meigs.

Calvin S. Stillwagner, a recruit from Kalamazoo, Michigan, wrote home in February 1918 that life at Camp Meigs could be demanding:

> *I was detailed for kitchen police duty yesterday. When they called names at retreat Saturday evening to report for "K.P." duty I did not know whether it meant a disease or a habit, but yesterday found out that it was real work. I washed more pans and other kitchen tools than ever before in my life, also cut more bread and scrubbed more floors, and at meal time my official duty was to draw the coffee. I sort of liked that job.*[91]

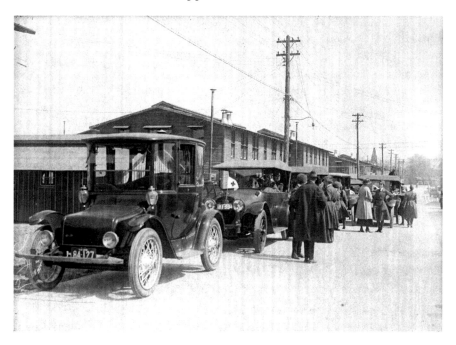

A Red Cross motorcade stopped at Camp Meigs in 1918. *Library of Congress.*

The camp was actually a rather posh posting, especially in comparison to the trenches of the Western Front. Beyond the tidy barracks neatly ranged along paved streets were athletic fields, including a baseball diamond and running track; a YMCA hut with music and movies; and, near the top of the hill, a $10,000 swimming pool donated by Mrs. Edward L. Doheny, wife of a California oil tycoon. Being on the outskirts of town, the camp was also well positioned to weather the Spanish flu epidemic in the fall of 1918 with relatively few casualties. In fact, once the city's theaters were allowed to reopen in November after the worst of the epidemic had passed, Camp Meigs's own drama company staged a lavish musical called *Atta Boy* at Poli's Theater on Pennsylvania Avenue. Professionally produced by camp members who were veterans of the New York stage, the all-male production included "chorus girls" and "nurses" played by soldiers in drag. After selling out at Poli's, the show staged an encore run at the Belasco Theater on Lafayette Square and was playing there when the armistice was signed ending the war.

Camp Meigs was closed down by 1920, and its facilities were sold for scrap. Local hardware magnate Sidney L. Hechinger (1885–1958) profited from sale of the scrap and opened one of his first stores on part of the site.

Even before the camp had been built, local officials had proposed turning the Patterson estate into a park, and after the military left the proposals became more urgent. The athletic fields and fine Doheny swimming pool were already in place, making for an ideal neighborhood recreational site. All that was needed was for Congress to appropriate the funds to purchase the property, something that unfortunately never happened.

Throughout the 1920s, the empty tract was used for as a venue for traveling shows, including Ringling Bros. and Barnum & Bailey Circus, which set up its tents on the lot every year. The *Washington Post* reported in 1921 that more than one hundred railroad cars full of people, animals and equipment arrived from Philadelphia that May for the annual event. The site's location near the railroad tracks of course made it particularly convenient. Other large events included a Ford Motor Company exhibition of $3 million worth of tractors, as well as a large Wild West circus, called the Miller Bros. 101 Ranch, which came to the Camp Meigs site almost as many times as the circus did.

The struggle to have the tract turned into parkland continued through the 1920s, with ultimately a small portion of the site on its northeast corner being acquired for a playground. Meanwhile, in the late 1920s, as plans progressed to tear down the venerable Center Market downtown, wholesale merchants who operated there began looking for a new site for their warehouses. In February 1931, one month after Center Market closed, a new Union Terminal Market was opened at the Camp Meigs tract. Plenty of space and proximity to the railroad made it an ideal location for a wholesale market that was intended to be a "feeder" for grocery stores and restaurants throughout the city. A farmers' market in a large warehouse was opened there as well, and for many years to come, savvy Washingtonians knew that this was to place to come for the lowest prices and for exotic foods and other merchandise that couldn't be found anywhere else in the city. The marketplace is still in operation, although proposals have been made to redevelop the property for mixed commercial and residential use. Few people realize that a World War I camp used to be on this site, and fewer still are aware of the graceful mansion that used to sit proudly on top of the hill.

TAKOMA PARK, TERRA COTTA AND THE TRAINS

The town of Takoma Park, straddling the border between D.C. and Maryland, began in 1883 as an isolated outpost on the Metropolitan Branch of the Baltimore & Ohio Railroad, one of the very first commuter suburbs

of Washington. Planned as a place of peace and tranquility, the little suburb stood in stark contrast to the desolate industrial neighborhood known as Terra Cotta, just to the south, which witnessed a terrible accident in 1906.

Takoma Park was the brainchild of Benjamin Franklin Gilbert (1841–1907), a New York native who came to Washington during the Civil War to find business opportunities in the midst of the national crisis. He ran a restaurant on F Street downtown called the Temperance Dining Room, which gives you a sense of his ideological leanings. By the 1880s, he had dabbled in downtown real estate and was looking for greater opportunities. Meanwhile, the B&O had opened its Metropolitan branch line in 1873. While the B&O mainline headed east from downtown D.C. toward Baltimore, the Metropolitan ran north to Point of Rocks, Maryland, near the West Virginia border. The railroad was offering to support development along its new line, and Gilbert decided to jump at this opportunity.

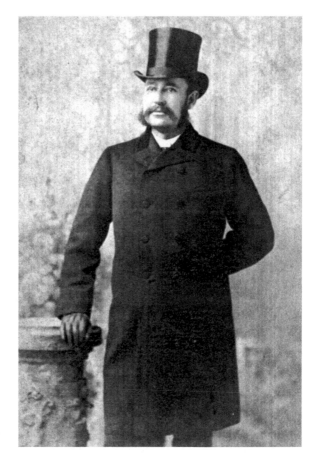

Benjamin Franklin Gilbert.
Historic Takoma, Inc.

In 1883, he purchased an eight-hundred-acre tract of land where the railroad tracks crossed into Maryland and started a development there that he called Tacoma, a Native American word meaning "high up, near heaven." The name was soon changed to Takoma Park, distinguishing it from Tacoma, Washington, and emphasizing its suburban serenity. A rough, wooded area with no infrastructure, the spot nevertheless had several things going for it: fresh water from nearby springs and the Sligo Creek, a 350-foot elevation that kept the air cool and largely mosquito-free in the summer and, perhaps most importantly, the fact that the rail line ran through it, offering commuters an easy twenty-minute trip to central Washington.

Gilbert's Takoma Park development was as much a realization of his romantic ideals about pure suburban life as it was a practical business venture. He priced his house lots cheaply enough that a middle-class wage earner could afford them, at the same time luring them out of the city with the promise of clean, suburban living. The sale of "coffin varnish" (alcohol), for example, was strictly prohibited.

In addition to beautiful and spacious Queen Anne houses that sprang up on the development's new lots, a small commercial strip developed along the railroad tracks that had the look and feel of a genuine frontier town. At its heart was an elegant little train station, designed by railroad architect Ephraim Francis Baldwin (1837–1916), which the B&O completed in 1886. The station played a key role in what the *Washington Herald* called the "grimmest and most awful tragedy of modern times,"[92] which occurred during the 1906 holiday season at tiny Terra Cotta, a rather barren, semi-industrial spot inhabited mostly by workmen from the National Terra Cotta Works of the Thomas Somerville Company and a few smaller tile factories.

It was a Sunday afternoon—December 30, to be exact—when a three-car passenger train left Frederick, Maryland, on a very slow run south to Washington, stopping at each village and hamlet along the way. Local 66 was an "accommodation" train designed to give people visiting relatives in Maryland a way to get back into town at the end of the weekend, and over the holidays many people had taken advantage of it, including many families with small children. When the train passed through Takoma Park at 6:26 p.m., it was crowded and running late, which was far from unusual. The passengers were tired; some had been standing in the aisles of the three wooden passenger cars for more than an hour. Others ate apples or sandwiches that they had brought along, knowing that they'd be home late for supper. The train next stopped briefly at Terra Cotta, less than a mile

A train passes the station at Takoma Park. *Historic Takoma, Inc.*

south of Takoma Park. The stop after that was supposed to be Catholic University in Brookland. It was after nightfall, and the entire area was blanketed in a thick, impenetrable fog.

As described in the *New York Times*, witnesses were stunned by what happened next. Another train, number 2120, known as a "dead-head" train because it was pulling a string of empty cars, came speeding south toward Takoma Park at forty or fifty miles per hour, only seven minutes after the pokey accommodation train had passed through. Milton W. Phillips, the telegraph operator at the Takoma Park station, had set a red signal to keep such trains from proceeding toward Terra Cotta until the accommodation train had passed safely through, but the dead-head train barreled right past. Astounded, Phillips frantically tapped out a message to the next telegraph station, at Catholic U: "2120 by my red light, going like hell." But he knew that there was simply no time left to prevent a terrible disaster.

The local accommodation train included a heavy coal car at its rear, behind its three wooden passenger cars. The speeding dead-head train, headed by one of the B&O's largest and most powerful locomotives, rammed the coal car straight through two of the three wooden passenger cars, splintering them into thousands of pieces that were strewn for three-quarters of a mile along the track, before telescoping into the third car and coming to rest behind the local train's locomotive, which it pushed nearly a mile to the south. Along the tracks behind them, two of the packed carloads of passengers had been completely obliterated.

The dense fog shrouded the scene of the disaster, making rescue efforts maddeningly difficult. Human beings, alive and dead, had been scattered widely into the night, some thrown clear, others mixed in with twisted steel and splintered wood, all covered with thick black ash from the smashed coal car. First, priests from the Franciscan Monastery in nearby Brookland, having heard the crash, arrived and did what they could for the injured by lantern light. Eventually, two special trainloads of rescuers arrived.

Amazing stories soon emerged about the survivors. Young George Burgless, for example, had just helped his mother and sister onto the train at Terra Cotta and was standing on the platform when he saw the oncoming train and realized what was about to happen. Leaping onboard, he shoved the two women back out and jumped after them to the ground; they were all injured in the fall and from flying wood splinters but were otherwise fine. Far sadder and more numerous were the stories of mothers and fathers looking for sons or daughters, babies found miraculously alive with no trace of a parent and rescue workers unable to identify mangled human remains. The *Washington Times* carried the poignant story of young Maurice Sturgeon, who was in anguish after his twenty-year-old wife and thirteen-month-old son were both killed in the crash—the infant having initially survived, only to succumb within hours at Providence Hospital. Later, the distraught husband had them buried together in the same casket. The final toll from the disaster was forty-three killed, sixty-three seriously wounded.

The engineer of the dead-head train, Harry H. Hildebrand, and his entire crew, along with Milton Phillips, the Takoma Park telegraph operator, were all immediately arrested and jailed, and by the time the newspapers came out with the story, Hildebrand was already being blamed for running the red light at Takoma Park. But the case quickly grew complicated. Hildebrand had been on duty for forty-eight hours with only eight intermittent hours of sleep. He claimed not to have seen the red signal at Takoma Park. Further, the Takoma Park station was supposed to have closed for the day at 6:30 p.m., and thus no signal was expected. Furthermore, the previous station, at Silver Spring, had displayed a "double green" signal, meaning that all was clear but to proceed with caution. Hildebrand said that he thought that meant that the accommodation train was not in his path. The jury in a coroner's inquest held just days after the accident blamed everybody, including the crew of both trains, the operators at all three stations and the management and safety procedures of the railroad as a whole.

From the perspective of history, it seems clear that Hildebrand—tired and annoyed as he likely was from working overly long hours and being forced

to take a long detour to get back home to Baltimore—acted recklessly and caused the accident. But when Hildebrand and his crew were put on trial nearly a year later, they were all acquitted. "I could not think these men would run past a danger signal…and thereby place their own lives in peril," the jury foreman explained. "There was blame somewhere for this awful disaster, but I could never send these men to the penitentiary for it."[93]

Of Terra Cotta, the day after the tragedy, the *New York Times* had written, "The whole neighborhood is one of evil repute for accidents, a neighborhood of which many tales are told of trains rushing down grades and around curves at high speeds, and lives have been lost there more than once."[94] True to its reputation, perilous Terra Cotta claimed still more lives in a tragic Metrorail subway accident in June 2009. Once again, a train running downhill toward central Washington slammed into another train; this time, the lead car of the approaching train was splintered as it crashed into the stopped train. Nine people were killed and fifty-two others taken to hospitals. The National Transportation Safety Board concluded that a crucial signaling system had failed.

Lost Washington, DC Historic Sites

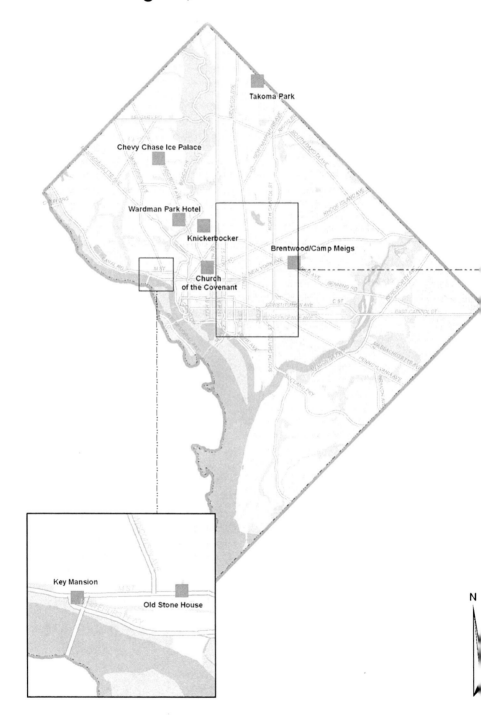

Takoma Park

Chevy Chase Ice Palace

Wardman Park Hotel

Knickerbocker

Brentwood/Camp Meigs

Church
of the Covenant

Key Mansion

Old Stone House

N

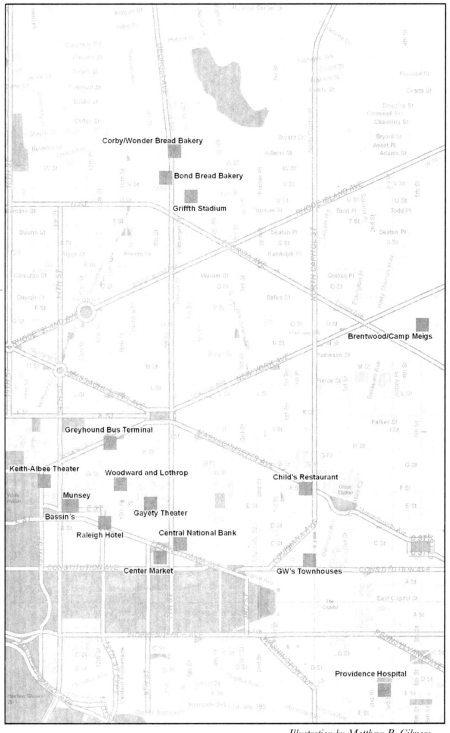

Corby/Wonder Bread Bakery

Bond Bread Bakery

Griffth Stadium

Brentwood/Camp Meigs

Greyhound Bus Terminal

Keith-Albee Theater

Woodward and Lothrop

Child's Restaurant

Munsey

Bassin's

Gayety Theater

Raleigh Hotel

Central National Bank

Center Market

GW's Townhouses

Providence Hospital

Illustration by Matthew B. Gilmore.

Notes

Glimpses of Capitol Hill

1. George Washington to William Thornton, December 20, 1798, in the George Washington Papers at the Library of Congress, 1741–1799, Series 2 Letterbooks.
2. George Washington to John Avery, September 25, 1799, in Davis, Dorsey and Hall, *Georgetown Houses of the Federal Period*, 112.
3. Pitch, *Burning of Washington*, 113.
4. Looker, "Washington's Houses on Capitol Hill," 69.
5. *Washington Post*, "Murder Baffles Law," May 18, 1901, 2.
6. *Washington Post*, "Interest in Kenmore Hotel," August 18, 1902, 10.
7. *Daily National Intelligencer*, "Providence Hospital, Washington," June 7, 1861.
8. Goode, *Capital Losses*, 432–33.
9. *Washington Post*, "Providence Hospital," January 4, 1886, 2.
10. James Daniel, "Carriages Used as Beds at Crowded D.C. Hospital," *Washington Daily News*, February 13, 1942.
11. Martha Strayer, "Stretchers Were Maternity Beds in Overflowing D.C. Hospital," *Washington Daily News*, March 10, 1948.

EVERYDAY LIFE ON PENNSYLVANIA AVENUE

12. Tangires, "Contested Space," 56.

13. Lessoff and Mauch, *Adolf Cluss Architect*, 159–65.

14. Philip D. Carter, "Louis B. Gatti Dies, Produce Merchant," *Washington Post*, December 20, 1969, C10.

15. *Washington Post*, "Mrs. Gatti, Presidents' Friend, Dies," March 27, 1948, B2.

16. *Washington Post*, "Are They Imposed Upon," September, 17, 1887, 2.

17. *Washington Post*, "Greek Hucksters Routed," July 26, 1896, 5.

18. *Washington Post*, "War Didn't Efface Them," December 11, 1892, 12.

19. *Washington Times*, "Quaint and Picturesque Markets of the Curb," April 27, 1902, 4.

20. See Smith, *A.B. Mullett*.

21. *Washington Post*, "A.B. Mullett's Suicide," October 21, 1890, 1.

22. Maddex, *Historic Buildings of Washington, D.C.*, 136.

23. Chanticleer, "Pall Mall Room at the Raleigh Proves Popular," *Washington Post*, November 25, 1936, X12.

24. Jay Carmody, "A Cultural Center—Old Style," *Evening Star*, February 2, 1969.

25. Britt, *Forty Years—Forty Millions*, 17.

26. Ibid., 208.

27. Pennsylvania Avenue Development Corporation, *Pennsylvania Avenue Plan 1974*, 32.

28. Landmarks Preservation Commission, *(Former) Childs Restaurant Building*.

29. H.I. Phillips, "The Once Over," *Washington Post*, March 13, 1929, 11.

30. *Washington Times*, "89 Cafes Adopt $1.00-A-Day Menus," October 10, 1918, 1.

31. *Washington Post*, "Lipscomb Company Completes $175,000 Restaurant Here," December 12, 1926, M18.

32. *Washington Post and Times-Herald*, "Last Childs Restaurant in District Closes Doors," February 11, 1955, 25.

33. Fossils in the Architecture of Washington, D.C., http://dcfossils.org/index.php/gallery13.

34. Kay Ware, "Childs Adopts 'Atmosphere' as New Motif," *Washington Post*, January 11, 1935, 11.

35. George Rothwell Brown, "Capital Silhouettes," *Washington Post*, November 1, 1923, 6.

36. Connie Feeley, "Sidewalk Cafe Proposal for City Stirs Up Contradictory Opinions," *Washington Post*, February 15, 1959, C8.

37. James R. Carberry, "The Difference Is, in Paris They Also Sip," *Washington Post*, March 17, 1961, D1.

38. John Pagones, "Newest Twist Room Has Gyrating Space," *Washington Post*, April 1, 1962, G4.

Downtown's Booming Businesses

39. *Washington Post*, "Cafritz Offers Keith's as Gift to City for Municipal Theater, Arts Center," July 11, 1959, D1.

40. *Washington Post*, "$40 Million Mall Is Planned," November 12, 1977, A1.

41. Anne H. Oman, "Building Preservation Sought in Commercial Complex Project," *Washington Post*, February 23, 1978, DC4.

42. See Allen, *Horrible Prettiness*.

43. Robert Denny, "Video Strips Washington of Its Gayety," *Washington Times-Herald*, January 31, 1950.

44. Leroy F. Aarons, "Jimmy Lake's Ninth Is an Unfinished Street," *Washington Post*, October 4, 1964, E2.

45. Guilford, *From Founders to Grandsons*, 70.

46. Ibid., 68.

47. *Washington Post*, "Old-Timers Don't Say Woodies," September 11, 1984, B2.

48. Longstreth, "Mixed Blessings of Success."

49. *Washington Post*, "Old-Timers Don't Say Woodies."

50. *Washington Post*, "New Greyhound Bus Terminal Is Rising," April 30, 1933, M8.

51. *Washington Post*, "25,000 Dance in to Inspect New Greyhound Line Terminal," March 26, 1940, 28.

52. Wilson L. Scott, "Bus Terminal Is Busy Wartime Mecca," *Washington Times-Herald*, May 2, 1943.

53. *Washington Star*, "War-Bereaved Father Dies After Shooting Stranger and Himself," July 31, 1945.

54. Henry Allen, "Everybody's Here at Bus Station Nation," *Washington Post*, March 11, 1973, P12.

GEORGETOWN

55. *Washington Times*, "Quaint Bits of Washington of Historic Interest," December 7, 1902.
56. See Gahn, *George Washington's Headquarters in Georgetown*.
57. See Heine, *Old Stone House*.
58. William J. Brady, "Site of Suter's Tavern Pin-Pointed by Historian," *Washington Post*, September 4, 1955, A11.
59. See Hines, *Early Recollections of Washington City*.
60. F.S. Key Smith, "Our National Anthem," *Washington Post*, June 16, 1907, ES14.
61. Noel, "Preservation of the Residence of Francis Scott Key."
62. For a discussion of the possibilities concerning the loss of the house remnants, see Mackintosh, "Loss of the Francis Scott Key House."

DUPONT CIRCLE AND ADAMS MORGAN

63. Goode, *Capital Losses*, 246.
64. *Washington Post*, "A High Tower in Ruins," August 23, 1888, 6.
65. Bains, "Capital Presence."
66. Wolf Von Eckardt, "All Elderly Stuff Fine Except Old Buildings," *Washington Post*, October 20, 1963, G8.
67. For a comprehensive discussion of the development of the motion picture business in Washington, D.C., see Headley, *Motion Picture Exhibition in Washington, D. C.*
68. *Washington Herald*, "Give $2,000,000 to See Movies," August 28, 1915.
69. *Washington Post*, "Hundreds, Dead or Injured, Buried Under Ruins as Roof of Knickerbocker Theater Collapses," January 29, 1922, 1.

HISTORIC SHAW

70. See, for example, "Clean Bread," a full-page advertisement in the *Washington Times*, July 26, 1908, 10, and "Bond Bread and Pure Milk— Both Are Safe Foods for Him," an advertisement in the *Washington Post*, December 15, 1919, 11.
71. *New York Times*, "War on Filthy Bakeries," April 8, 1896.

72. *Evening Star*, "The Staff of Life: How Bread Is Made in a Big Bakery," July 15, 1893.

73. Advertisement in the *Washington Times*, February 27, 1919, 15.

74. Werlin, "Corby's—Washington's Biggest Bakery," 101–2.

75. Wirz and Striner, *Washington Deco*, 89ff.

76. Benson, *Ballparks of North America*, 406.

77. *Baltimore Sun*, "The Girls After Umpire," September 15, 1897.

78. Snyder, *Beyond the Shadow of the Senators*, 4.

79. Ruble, *Washington's U Street*, 170.

UPPER NORTHWEST

80. Goode, *Capital Losses*, 160.

81. *Washington Post*, "Woodley Court Plans," December 31, 1916, FD2.

82. Carl Bernstein, "The Washington Wardman Built," *Washington Post*, February 16, 1969, 259.

83. *Washington Post*, "Chevy Chase Sports Center Opens November 23," November 20, 1938, R11.

84. *Washington Post*, "Kass Realty Co. Plans Shopping, Parking Center," July 11, 1937, R4.

85. Jack Munhall, "Skate Rink Opening Is Big Success," *Washington Post*, November 24, 1938, X19.

86. A.B. Amerson Jr., "Skaters Lament—Where to Skate?" *Evening Star*, February 22, 1970.

87. Peter Golkin, "Elvis on the Potomac," *Washington City Paper*, February 16, 2007.

UPPER NORTHEAST

88. Fazio and Snadon, *Domestic Architecture of Benjamin Henry Latrobe*, 688–94.

89. Dunbar, *Poems of Cabin and Field*, 17.

90. *Washington Herald*, "Brentwood Manor Relic of City's Early Days," June 25, 1911, 4.

91. *Kalamazoo Gazette*, "Finds Kitchen Work Difficult," February 24, 1918.

92. *Washington Herald*, "City Is Stunned by the Tragedy," January 1, 1907, 1.

93. *Washington Post*, "Train Crew Acquitted," December 24, 1907, 2.

94. *New York Times*, "Wreck Kills 50 at Washington," December 31, 1906, 1.

SELECTED BIBLIOGRAPHY

Allen, Robert C. *Horrible Prettiness: Burlesque and American Culture*. Chapel Hill: University of North Carolina Press, 1991.

Ambrose, Kevin. *Blizzards and Snowstorms of Washington, D.C.* Merrifield, VA: Historical Enterprises, 1993.

Ashworth, Marjorie. *Glory Road: Pennsylvania Avenue Past & Present*. McLean, VA: Link Press, 1986.

Bains, David R. "A Capital Presence: The Presbyterian Quest for a 'National Church' in Washington, D.C." Unpublished manuscript, 2006.

Bednar, Michael. *L'Enfant's Legacy: Public Open Spaces in Washington, D.C.* Baltimore, MD: Johns Hopkins University Press, 2006.

Benson, Michael. *Ballparks of North America: A Comprehensive Historical Reference to Baseball Grounds, Yards, and Stadiums, 1845 to Present*. Jefferson, NC: McFarland & Company, 1989.

Bordewich, Fergus M. *Washington: The Making of the American Capital*. New York: HarperCollins, 2008.

Britt, George. *Forty Years—Forty Millions: The Career of Frank A. Munsey*. Port Washington, NY: Kennikat Press, 1972. Originally published in New York, 1935.

Brown, George Rothwell. *Washington: A Not Too Serious History*. Baltimore, MD: Norman Publishing Company, 1930.

Cary, Francine Curro. *Urban Odyssey: A Multicultural History of Washington, D.C.* Washington, D.C.: Smithsonian Institution Press, 1996.

Caulfield, Paul A., MD. "History of Providence Hospital, 1861–1961." *Records of the Columbia Historical Society.* Vols. 60/62. Washington, D.C.: Columbia Historical Society, 1963.

Davis, Deering, Stephen P. Dorsey and Ralph Cole Hall. *Georgetown Houses of the Federal Period.* Mineola, NY: Dover Publications, 2001. Originally published by Architectural Book Publishing Company, 1942.

Dunbar, Paul Laurence. *Poems of Cabin and Field.* New York: Dodd, Mead & Company, 1896.

Eberlein, Harold Donaldson, and Cortlandt Van Dyke Hubbard. *Historic Houses of George-Town & Washington City.* Richmond, VA: Dietz Press, 1958.

Elfin, Margery L., Paul K. Williams and the Forest Hills Neighborhood Alliance. *Forest Hills.* Charleston, SC: Arcadia Publishing, 2006.

Evelyn, Douglas E., and Paul Dickson. *On This Spot: Pinpointing the Past in Washington, D.C.* 4th ed. St. Petersburg, FL: Vandamere Press, 2010.

Ewing, Charles. *Yesterday's Washington, D.C.* Miami, FL: E.A. Seemann Publishing, Inc., 1976.

Fazio, Michael W., and Patrick A. Snadon. *The Domestic Architecture of Benjamin Henry Latrobe.* Baltimore, MD: Johns Hopkins University Press, 2006.

Fogle, Jeanne. *A Neighborhood Guide to Washington, D.C.'s Hidden History.* Charleston, SC: The History Press, 2009.

Gahn, Bessie Wilmarth. *George Washington's Headquarters in Georgetown, and Colonial Days, Rock Creek to the Falls.* Silver Spring, MD: Press of Westland, 1940.

Gomery, Douglas. "A Movie-Going Capital." *Washington History* 9, no. 1 (1997). Historical Society of Washington, D.C.

Goode, James M. *Best Addresses: A Century of Washington's Distinguished Apartment Houses.* 2nd ed. Washington, D.C.: Smithsonian Books, 2003.

———. *Capital Losses: A Cultural History of Washington's Destroyed Buildings.* 2nd ed. Washington, D.C.: Smithsonian Books, 2003.

————. *Washington Sculpture: A Cultural History of Outdoor Sculpture in the Nation's Capital.* 2nd ed. Baltimore, MD: Johns Hopkins University Press, 2008.

Green, Constance McLaughlin. *Washington: A History of the Capital, 1800–1950.* Princeton, NJ: Princeton University Press, 1962.

Guilford, Martha C. *From Founders to Grandsons: The Story of Woodward & Lothrop.* Washington, D.C.: Rufus H. Darby Printing Company, 1955.

Headley, Robert K. *Motion Picture Exhibition in Washington, D. C.: An Illustrated History of Parlors, Palaces & Multiplexes in the Metropolitan Area, 1894–1997.* Jefferson, NC: McFarland & Company, 1999.

Heine, Cornelius W. *The Old Stone House.* Washington, D.C.: National Park Service, 1955.

Hines, Christian. *Early Recollections of Washington City.* Washington, D.C.: Junior League of Washington, 1981. Originally published in Washington, D.C., 1866.

Historic Takoma, Inc. *Takoma Park.* Charleston, SC: Arcadia Publishing, 2011.

Hurd, Charles. *Washington Cavalcade.* New York: E.P. Dutton & Company, 1948.

Jacob, Kathryn Allamong. *Capital Elites: High Society in Washington, D.C., after the Civil War.* Washington, D.C.: Smithsonian Institution Press, 1995.

Junior League of Washington. *The City of Washington: An Illustrated History.* New York: Wings Books, 1992. Originally published in Washington, D.C., 1977.

Landmarks Preservation Commission (New York). "(Former) Childs Restaurant Building." Designation List 344 LP-2106, February 4, 2003. www.nyc.gov/html/lpc/downloads/pdf/reports/childs.pdf.

Lessoff, Alan. *The Nation and Its City: Politics, "Corruption," and Progress in Washington, D.C., 1861–1902.* Baltimore, MD: Johns Hopkins University Press, 1994.

Lessoff, Alan, and Christof Mauch, eds. *Adolf Cluss Architect: From Germany to America.* Washington, D.C.: Historical Society of Washington, D.C., 2005.

Levey, Bob, and Jane Freundel. *Washington Album: A Pictorial History of the Nation's Capital.* Washington, D.C.: Washington Post Books, 2000.

Longstreth, Richard. "The Mixed Blessings of Success: The Hecht Company and Department Store Branch Development after World War II." *Perspectives in Vernacular Architecture.* Vol. 6. Harrisonburg, VA: Vernacular Architecture Forum, 1997.

Looker, Henry B. "Washington's Houses on Capitol Hill." *Records of the Columbia Historical Society.* Vol. 7. Washington, D.C.: Columbia Historical Society, 1904.

Mackintosh, Barry. "The Loss of the Francis Scott Key House: Was It Really?" Washington, D.C.: National Park Service, 1981.

Maddex, Diane. *Historic Buildings of Washington, D.C.* Pittsburgh, PA: Ober Park Associates, Inc., 1973.

Marsh, Ellen R., and Mary Anne O'Boyle. *Takoma Park: Portrait of a Victorian Suburb 1883–1983.* Takoma Park, MD: Historic Takoma, Inc., 1984.

Miller, Hope Ridings. *Great Houses of Washington, D.C.* New York: Clarkson N. Potter, Inc., 1969.

National Capital Planning Commission. *Downtown Urban Renewal Area Landmarks Washington, D.C.* Washington, D.C.: U.S. Government Printing Office, 1970.

Noel, F. Regis. "Preservation of the Residence of Francis Scott Key: A Possible Home for the Columbia Historical Society." Washington, D.C.: Columbia Historical Society, 1947.

Pennsylvania Avenue Development Corporation. *The Pennsylvania Avenue Plan 1974.* Washington, D.C.: self-published, 1974.

Pitch, Anthony S. *The Burning of Washington: The British Invasion of 1814.* Annapolis, MD: Naval Institute Press, 1998.

Poore, Benjamin Perley. *Perley's Reminiscences of Sixty Years in the National Metropolis.* Philadelphia, PA: Hubbard Brothers Publishers, 1886.

Reiff, Daniel D. *Washington Architecture 1791–1861: Problems in Development.* Washington, D.C.: U.S. Commission of Fine Arts, 1971.

Roberts, James C. *The Nationals' Past Times: The History and New Beginning of Baseball in Washington, D.C.* Chicago, IL: Triumph Books, 2005.

Ruble, Blair A. *Washington's U Street: A Biography.* Washington, D.C.: Woodrow Wilson Center Press, 2010.

Scott, Pamela, and Antoinette J. Lee. *Buildings of the District of Columbia.* New York: Oxford University Press, 1993.

Smith, Daisy Mullett. *A.B. Mullett: His Relevance in American Architecture and Historic Preservation.* Washington, D.C.: Mullett-Smith Press, 1990.

Smith, Kathryn Schneider. *Washington at Home: An Illustrated History of Neighborhoods in the Nation's Capital.* 2nd ed. Baltimore, MD: Johns Hopkins University Press, 2010.

Snyder, Brad. *Beyond the Shadow of the Senators: The Untold Story of the Homestead Grays and the Integration of Baseball.* Chicago, IL: Contemporary Books, 2003.

Tangires, Helen. "Contested Space: The Life and Death of Center Market." *Washington History* 7, no. 1 (Spring/Summer 1995).

Topham, Washington. "Centre Market and Vicinity." *Records of the Columbia Historical Society.* Vol. 26. Washington, D.C.: Columbia Historical Society, 1924.

Werlin, Otto. "Corby's—Washington's Biggest Bakery." *Bakers Review* 32, no. 1 (October 1915). Wm. R. Gregory Company, New York.

Williams, Paul K. *Dupont Circle.* Charleston, SC: Arcadia Publishing, 2000.

———. *Greater U Street.* Charleston, SC: Arcadia Publishing, 2002.

Wirz, Hans, and Richard Striner. *Washington Deco: Art Deco in the Nation's Capital.* Washington, D.C.: Smithsonian Institution Press, 1984.

INDEX

INDEX

About the Author

John DeFerrari, a native Washingtonian with a lifelong passion for local history, pens the Streets of Washington blog devoted to the history of the District of Columbia. He has a master's degree in English literature from Harvard University and works for the federal government.

Photo by Austin J. Cuttino.